THE VANITY OF SMALL DIFFERENCES

Grayson Perry

SOUTHBANK CENTRE **HAYWARD PUBLISHING**

Foreword

The Germans live in Germany,
The Romans live in Rome,
The Turkeys live in Turkey;
But the English live at home.

J.H. Goring, *The Ballad of Lake Laloo, and other rhymes*, 1909

THOSE WHO KNEW GRAYSON PERRY'S WORK in the 1990s will remember its largely autobiographical content: explorations of his growing up in Essex, his emerging sexuality and *alter ego* Clare, as well as his attachment to his childhood teddy bear, Alan Measles. Since the early 2000s, his work has developed as acute social commentary; I am thinking here of a pot (*Boring Cool People*, 1999) lampooning city types in designer suits, brandishing mobile phones, or perhaps the one that responds to florid tabloid reports of child murder, called *We've Found the Body of Your Child* (2000). Now, with his TV work, Perry has ventured into a territory that is frankly, but affectionately, anthropological or pseudo-ethnographic.

In 2008, Perry curated an exhibition of works from the Arts Council Collection, which proved to be one of the most successful we have ever mounted: the wildly popular *Unpopular Culture* toured the UK for two years, with Perry's idiosyncratic selection of paintings, documentary photographs and small sculptures epitomising a particular understanding of England as it was during his youth in the 1960s and 70s. The success of that exhibition derived, not only from Perry's sharp curatorial eye, but from his ability to put his finger on the reigning zeitgeist, creating a narrative of Englishness that resonated precisely with a broad public. The three television programmes on Channel 4 that comprised the documentary series *All in the Best Possible Taste with Grayson Perry* (2012) are a natural extension of this trajectory, taking the artist from detached commentary into actual fieldwork, as a wry recorder of contemporary tastes and mores.

All of these observations are distilled into the suite of tapestries that Perry, with his gallery Victoria Miro and Channel 4, and the Art Fund, Sfumato Foundation and AlixPartners, have so generously

gifted to the Arts Council Collection and British Council. This is the first time that these two collections have ever acquired a work in joint ownership, but it is at the same time highly appropriate. Since World War II, both collections have been dedicated to the support of British artists and to their promotion in the UK and overseas. As a consequence, we are, in some respects, experts in 'Britishness', although we would never presume to define what that is. The image of Britain that is reflected in both collections is inclusive, diverse – quirky, possibly, but also demonstrably self-critical and always questioning.

The six tapestries that comprise the suite presented here are a record of an artist's explorations of class, of the history of three different regions of England, and, most particularly, of a precise moment in our history. In one hundred years' time, the observations encapsulated here will be as historically circumscribed as William Hogarth's *A Rake's Progress* (1733), the series of paintings that form the template and inspiration for the travails of Perry's class hero Tim Rakewell. With the passing

of time will come the critical distance that crystallises political positions, as well as personal ones. For the moment, as we live in the moment, we are indebted to Suzanne Moore for her incisive, moving and highly personal reflections on questions of class, taste and their relative values; to Adam Lowe, for his expert discussion of tapestry in the digital age; and most especially to Grayson Perry for his gift. We would also like to thank Pony for their inventive and elegant design for this publication.

Perry says that he always conceived *The Vanity of Small Differences* as a public work of art. Not one to work in monumental cast bronze for city squares, Perry's public artwork will have a uniquely mobile existence henceforth, touring the UK and beyond to surreptitiously poke we Brits in the ribs, and remind us of our endearing pretensions, our prideful weaknesses and, most essentially, our ability to laugh at ourselves.

Caroline Douglas
Head of Arts Council Collection

The Vanity of Small Differences
GRAYSON PERRY

THE ARTWORKS IN THIS BOOK came out of making a three-part, documentary television series for Channel 4 called *All in the Best Possible Taste with Grayson Perry* (2012), directed by Neil Crombie.

When we were filming the series, one of the encounters that most haunted me was with Jayne Newman, who lived on a new housing development called King's Hill near Tunbridge Wells in Kent. I wanted to talk to her because she had bought one of the show flats, fully furnished and decorated by the developer. When she moved in, it even had a bathrobe that the interior decorator had chosen hanging on the back of the bathroom door. She had decided to give up a right seen as sacred by most middle-class people, the right to express one's individuality through one's home. The few items she had added to the flat fitted in seamlessly. She said she had bought it because there was so much choice out there and she had a fear of getting it wrong. The show flat had been kitted out in an okay style: neutral tones, unfussy sofas, bland knick-knacks. On her own she might have made a hash of it – she might have, God forbid… bad taste! This was a revelation to me. I had spent a lifetime enjoying control over my aesthetic choices, revelling in it; here was someone admitting to a wholesale avoidance of such decisions.

Ever since I was a child I have been very aware of the visual environment people build around themselves and, when I got older, I wanted to decode their choices. Why did my Nan's front room, with its brass ornaments and pot plants, look like it did? Why do middle-class people love organic food and recycling? Why does the owner of a castle and 6,000 acres wear a threadbare tweed jacket? People seem to be curating their possessions to communicate consciously, or more often unconsciously, where they want to fit into society.

Ask people about taste and they are very happy to list what they regard as bad taste. A middle-class person will talk of their revulsion for taste choices they regard as vulgar or working class. Their dislike, their desire to define themselves against what they regard as an awful 'other', is so embodied that they often express physical disgust. Ask them to list things they regard as good taste, and people are much more reticent. To ally oneself with a style choice is to make oneself vulnerable to criticism. Taste is a tender subject. What really fascinates me about the topic of aesthetic taste is that people really *care*.

The British care about taste because it is inextricably woven into our system of social class. I think that – more than any other factor, more than age, race, religion or sexuality – one's social class determines one's taste. Anthropologist Kate Fox, in her brilliant and hilarious book *Watching the English* (2004), observes that, even amidst the homogenised dress codes of youth, class plays a part. A middle-class teenager may still wear a hoodie but it will be a more cotton-rich brand, or they will sport a toned-down version of the fashionable haircut, such is the pervasiveness of bourgeois regard for authenticity and restraint.

I am not an anthropologist, though; neither am I a sociologist or a design historian. I am an artist, so I wanted to use the opportunity of making the TV series to research a series of artworks about class and taste. I chose to make a series of six tapestries. I usually choose a medium because of the resonances it has acquired; tapestries are

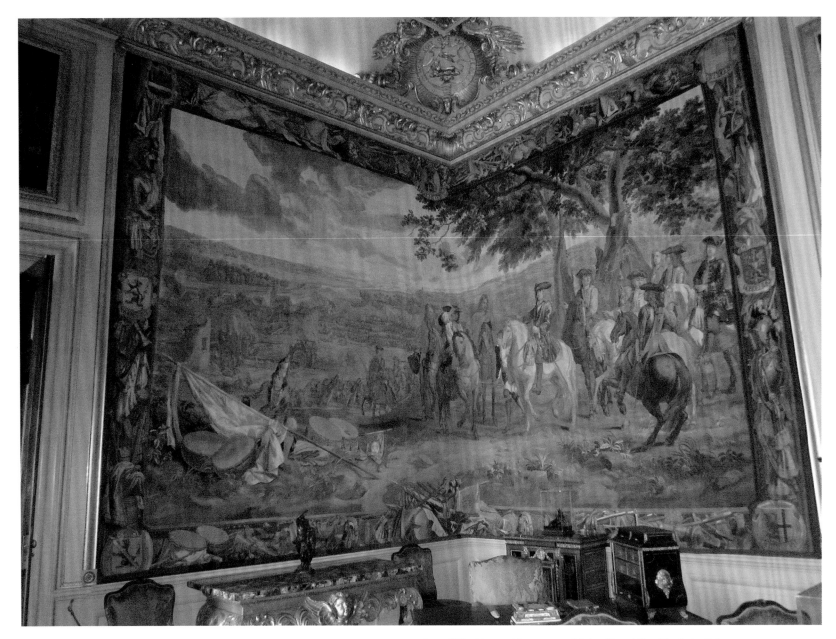

One of *The Victory Tapestries of John Churchill* at Blenheim Palace, Oxfordshire, showing John Churchill, the 1st Duke of Marlborough, accepting the surrender of the French at the Battle of Blenheim in 1704.*

*captions throughout written by Grayson Perry, except pp. 102, 104, 106 and 113.

grand – they hang in the vast saloons and bedchambers of ancestral piles, they often depict Classical myths or military victories. A lot of the status associated with tapestries, historically, was due to their huge cost and the enormous amount of skilled labour needed to produce them. The antique examples I encountered in stately homes such as Berkeley Castle in Gloucestershire, or Blenheim Palace in Oxfordshire, would have taken teams of workers many months, if not years, to weave.

Tapestries are still expensive to make today but, ironically, one of the attractions of using tapestry now is the relative speed with which I can produce a substantial artwork, compared to other media in which I enjoy working, such as ceramics or etching. Like many historical tapestries, mine were made in Flanders but, in the digital age, I designed them using Photoshop software and they were woven at dazzling speed on a huge computer-controlled loom that can produce a four-by-two-metre tapestry in just five hours. Skilled labour is still involved, but is performed by specialist computer technicians, who converted my drawing into the vast digital file that controlled the loom (see Adam Lowe's discussion of this process on p. 103).

Because of its large scale and the ease of transportation, tapestry also works well as a public artwork, and I am truly delighted that this series is now able to tour under the auspices of the Arts Council and British Council Collections.

I thought it refreshing to use tapestries – traditionally status symbols of the rich – to depict a commonplace drama (though not as common as it should be): the drama of social mobility. As a working-class, grammar school boy from the tail-end of the 'baby boomer' generation, social mobility is a theme close to my heart.

Politicians sometimes talk of a classless society, but I think the class system still thrives, though perhaps in a more hydra-headed form than in the days of flat caps, bowlers and toppers. As recently as twenty years ago, most people would describe themselves as definitely working class. Now, depending on the economic climate, between half and two-thirds define themselves as middle class, and this seems to depend on whether the survey includes the category 'upper working class' as an option for those insecure about their status. In the boom times, a plumber who has bought his council house in Manchester, an accountant in a suburban villa in Birmingham and a media executive in a trendy flat in London might all describe themselves as middle class. They may all earn similar, middle-class incomes, but they are still likely to be separated by a gulf of taste.

As we oiks climb the greasy pole, we may pick up a deceptively authentic-looking set of middle-class predilections: a book-lined study, a modest grubby car, a full wine rack and original window frames. All the while, from deep inside our urbane metropolitan exterior, an embarrassing former self wails from his oubliette: 'I want a gold Porsche'. As we will see, such a primal desire for the gew-gaws of one's culture of origin lead to the downfall of my hero, Tim Rakewell.

Class is something bred into us like a religious faith. We drink in our aesthetic heritage with our mother's milk, with our mates at the pub, or on the playing fields of Eton. We learn the texture of our place in the world from the curlicue of a neck tattoo, the clank of a Le Creuset casserole dish, or the scent of a mouldering hunting print. A childhood spent marinating in the material culture of one's class means taste is soaked right through you. Cut me and, beneath the thick crust of Islington, it still says 'Essex' all the way through.

As with many aspects of our behavior, a lot of the interesting stuff happens when we think we are not even making a decision. It's those default settings we all have, those unexamined 'natural' and 'normal' choices, which often say the most about us: where and when we eat, when and where we might expose a bit of flesh, the kind of curtains we buy, what you watch on TV, how you bring up your children. We often only become aware of these unconscious choices when we move between social classes. I think my middle-class wife screamed when I first came into the kitchen without a shirt on.

I have called my series of tapestries *The Vanity of Small Differences*. This title comes from a phrase 'the narcissism of small differences', used by Sigmund Freud in *Civilisation and its Discontents* (1929-30), alluding to the fact that we often most passionately defend our uniqueness when differentiating ourselves from those who are very nearly the same as us. Middle-class people are often the ones who put most store in being seen as 'individual'. Many an aspirational consumer 'knows' that it is their unique eclectic taste that pioneered the bowl of polished pebbles that hints at their deep spirituality; it was their infallible eye for cool that alighted on that vintage-style Union Jack cushion, quirky African fabric, or classic Eames chair. All the other people with unique, eclectic taste were, of course, just fashion victims. Growing up in a middle-class family, with its reverence for education and culture, gives these consumers the tools and the power with which to define what they see as 'good taste'. A big part of middle-class-ness is defining oneself as different, seeing one's taste as 'normal' and other people's as 'not right'.

The artistic inspiration for *The Vanity of Small Differences* came from several sources. The overall concept came from someone

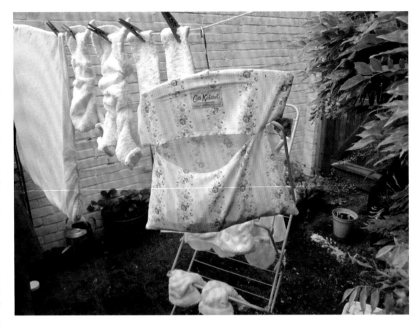

A Cath Kidston peg bag and re-usable nappies hung out to dry – an image that encapsulates both the middle-class desire for nostalgic authenticity and the guilt-assuaging power of an ecological morality.

I regard as the lodestone of British art – William Hogarth. In his most famous work, *A Rakes Progress* (1733), he tells, in a series of eight paintings, the story of Tom Rakewell, a young man who inherits a fortune from his miserly father, spends it all on fashionable pursuits and gambling, marries for money, gambles away a second fortune, goes to debtor's prison and dies in a madhouse. Hogarth has long been an influence on my work. I identify with his Englishness, his robust humour and his depiction of, in his own words, 'modern moral subjects'.

In the second painting of *A Rake's Progress,* called *The Levee,* Hogarth satirises the taste of the newly wealthy Tom. He has already attracted hangers-on, who illustrate some of the excesses of the *nouveau riche* in Georgian London. Among those in attendance are dancing and fencing masters in the French style, a fashion much derided by Hogarth. In the background hang some of Tom's recent acquisitions: three old master paintings, which Hogarth would have disapproved of, calling them 'dark pictures' and preferring modern paintings by English artists.

Hogarth might not approve, but each of my tapestries also makes reference to various famous old master paintings. Making knowing reference to older artworks is in itself a very middle-class thing to do, as it flatters the education and cultural capital of the audience. The paintings I borrow from are mainly early Renaissance religious works, as encapsulated by the collection shown in the Sainsbury Wing of the National Gallery, London. This is my favourite era of art and, as this series is very much a public work, I wanted to use the audience's familiarity with the Christian narratives depicted to lend weight to my own modern moral subject.

In my series of six works we follow the life of Tim Rakewell, from humble birth to famous death. The main thread of this journey is his progress through the social strata of modern British society. Nearly all of the places, people and objects that feature in the work were inspired by my televised taste safari.

We chose the three locations for our TV series – Sunderland, Tunbridge Wells and the Cotswolds – because they are each already strongly identified with the social classes. Sunderland has a proud working-class heritage from its heyday as a mining and shipbuilding town. The phrase 'Disgusted of Tunbridge Wells' – referring to a fictional writer of letters of complaint, invented by staff at the *Tunbridge Wells Advertiser* in the 1950s – makes this town almost synonymous with conservative middle-class values. The Cotswolds have also become associated with a deeply-rooted, landed upper class, due to the prevalence of mellow, limestone stately homes amongst the rolling hills of this scenic area.

Within each social group, taste seems to play a slightly different role. When I asked club singer Sean Foster-Conley what I should feature in my tapestries to show working-class taste, he said 'the mines and shipyards'. 'But they no longer exist,' I replied. In a very important way, however, he was right. The heavy industries that shaped the north of England also shaped the emotional lives of the generations of people who lived there. Winding towers and cranes can be torn down in a day, but the bonds, formed through shared hardship working under them, live on. The embodied tradition of feeling, the emotional structure of a place, takes a lot longer to decay. Taste is an emotional business; working-class people often talk of a strong sense of community, and taste decisions are often made to demonstrate loyalty to the clan. Now that those communities are no longer held together by working in the same mine, mill or shipyard, call-centre workers or spray-tanners pledge allegiance to a locale, to their friends and family, through

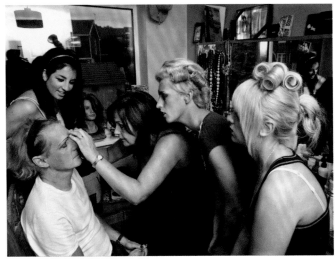

football, soap operas, body-building, tattoos, hot cars, elaborate hairstyles and the ritual of dressing up for a Friday night on the town. Energy is concentrated on the body, clothes, hair or cars – things to display in the social realm rather than the private home.

Taste seems a less tortured business for the working class than amongst the middle classes, as the pressure to be different from your neighbours is not as strong. This also seemed to me to be true of the upper class. Amongst the gentry, taste also binds the tribe, but not much personal expression seems to be involved. The word that kept cropping up with the people I met was 'appropriate'. The owners of grand country houses were custodians of a scene that they were unwilling to let change. They felt deeply obliged to maintain these landmarks and the roles that come with them. Curiously, having to preserve these beautiful and costly piles has helped form the overriding aesthetic of the upper class – one of refined entropy. The houses are lovingly patched, a man wears his grandfather's coat, the sofa collapses, and the creation of a museum of clutter is blithely encouraged.

Talking to Rollo and Janie Clifford, who own four Grade I listed properties in Gloucestershire, I thought they took pleasure from a crumbling stone staircase or her fifty-year-old car, covered in stickers. When quizzed, they denied an attachment to hard-won decay and pleaded poverty. When I pointed out that Rollo carried around his papers held together by a metal clip attached to a stump of dog-chewed cardboard when he could probably afford a new clipboard, he very grudgingly admitted to a appreciation of *patina*. How much of this is due to lack of funds and how much to inbred taste I do not know, but, as an Englishman, even a jumped-up prole like me feels genetically drawn to crumbling, faded glory.

The older generation's cherished ornaments include relics, such as a miner's lamp (opposite, top), of a harsher but even more communal industrial past.

Debra Anne Ratcliffe, a professional beautician, prepares me for the ritual Friday night out with friends Alexandra Sparks, Katherine Adamson and Laura Gooch (opposite, below). Both these scenarios fed into the first tapestry, *The Adoration of the Cage Fighters* (p. 67).

I found this battered and patched high chair (right) in a corridor of Chavenage House, a grand Elizabethan manor-house in Tetbury, Gloucester. Scrimping has become a lifestyle for stately home-owners, but I suspect the delightful and hilarious owner, David Lowsley-Williams – a man with the largest model railway I have ever seen – could probably afford a new high chair for his grandchildren.

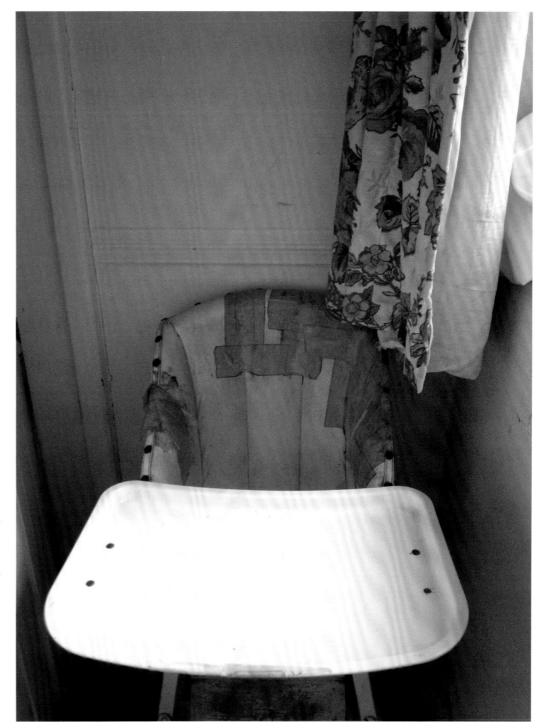

This elegantly arrested decomposition gives off useful signals: it says 'we are not in a hurry to change and upset anyone, we have owned this for ages and therefore are not billionaire incomers, who would install a swimming pool and electric gates'.

The drama of taste really gets going when people betray their aspiration to a higher social status through their purchases. The broad swathe of the British who describe themselves as the middle class are the ones most aware of, and also the most anxious about, taste.

At Kings Hill in Kent I encountered a set of unwritten rules. 'Discreet branding' was a phrase that cropped up – Prada loafers with a little badge, a Paul Smith shirt with tell-tale eccentric buttons, a 'low key' Rolex. Residents of these PVC clapboard houses sensed they had moved away from a tribe where crude bling gained respect, but they still needed the reassurance of an easily read code. Ostentation was still a difficult drug to resist – Range Rover Sports were everywhere and one resident poetically summed up the combination of pretention and banality when she described the estate as 'the only place you would see a Bentley parked on a roundabout'.

The ambience of the estate was maintained by a mixture of contractual obligation ('no caravans') and communal taboos ('no net curtains'). Talking to the residents, I found a genuine community spirit, but I sensed that for all of the convenience, security and luxury of their lifestyle, true middle-class status, if they actually wanted it, was beyond an intangible exclusion barrier. What that divide is made of, I think, is largely culture and education. The people basking on the sunlit uplands of the chattering classes have either passed through this miasmic barrier at university, or were born beyond it, where people just

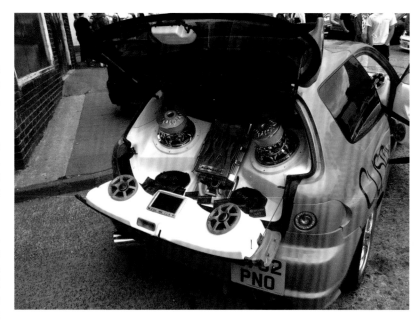

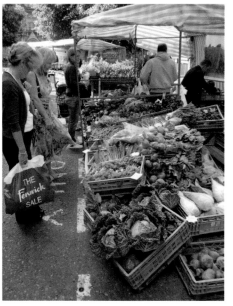

The owner of a hot hatchback blasts out ear-splitting mating calls in a Sunderland car park, whilst the upstanding citizens of Tunbridge Wells pay expensive penance for dirty vegetables at a farmers' market. Both are seeking status within their tribe, though one group might lay claim to a 'rational' argument for its consumer choices.

seem to know how to be fully middle class. Crucially, they understand that all the rules about taste that they have picked up by osmosis – when to wear shorts, what to name one's child, what to serve at a kitchen supper – none of them matter; one can flout them all as long as, and this is paramount, everyone knows you are doing it on purpose. So I can buy a Porsche and have it gold-plated, but it has to be full of rubbish and dog hair, and I must NEVER, EVER wash it.

Another driver of taste that I noticed amongst the upper middle class was the desire to show the world that one was an upright moral citizen. In the past, a good burgher might have regularly attended church or done voluntary work; today they buy organic, recycle, drive an electric car or deny their child television. This need to pay inconvenient penance to society seems to come partly from guilt. The liberal, educated middle class have done well, but they must pay with hard labour on their allotment, or by cycling to work.

Professional aesthetes in deconstructed suits and statement spectacles would love it if there were strict overarching rules of good taste like 'the golden section', or 'truth to materials'. I fear they search in vain. I started my research with a full set of prejudices about the 'inferior' taste of the working class I had left behind. I now find myself agreeing with cultural critic Stephen Bailey, that good taste is that which does not alienate your peers. Shared taste helps bind the tribe. It signals to fellow adherents of a particular subculture that you understand the rules. Within the group of, say, modified hatchback drivers, there is good and bad taste in loud cars in much the same way as there is good and bad taste in installations within the art world. Outsiders may find it baffling or irritating, but that is of less importance to insiders than impressing one's peers.

No Better Than They Ought To Be
SUZANNE MOORE

NOTHING MADE ME THINK MORE ABOUT TASTE than going through the possessions of a dead person that I had loved. To sort through the clothes and shoes and ornaments of my mother, who died way too young, sounds sad. It is the bit, after all, that most people dread, post-funeral: sifting through the possessions of a loved one. It is an autopsy of attachment – attachment to objects. What will be found in the silent sorting of a life's accoutrements? What will these things say of the life that has gone? What memories are there in a dress, or some special, unused cutlery, or someone's Sunday best? A friend, whose father was a collector of some repute, was surprised to discover, inside a box in which she hoped to find a valuable sculpture, a mildewed dildo. You never can tell.

For me, though, going through my mother's stuff was not a trial, but strangely wonderful. This was a veritable treasure trove of clothes and shoes, in which I saw the formation of her taste and therefore, inevitably, my own. I took what I wanted (our feet were the same size); I bagged up what I didn't. I wondered whether nature or nurture were responsible for the parallels in our taste.

What I found was the fantasy of the life she would have lead, had she been able, compared to the mundane one she ended up with. She was a good-looking woman, who had married an American and lived in the US. So, although solidly working class, she had glimpsed another life and tried to grasp hold of it. She was glamorous to me. I found shoes – deconstructed wedges that make Vivienne Westwood's look tame; zebra-skin handbags; amber cigarette holders for those sophisticated menthols. Oh yes, and a load of absolute tat. For, towards the end of her life, when she ran out of money and the men who would provide it, she became a hunter-gatherer at car boot sales, where the line between treasure and trash is fine indeed.

While her clothes were good (great, actually) her sense of interior decoration was firmly working-class and of its time. By this I mean cluttered and excessively decorative. Whichever house we lived in – and we moved constantly, up and down the same road sometimes, according to which husband/boyfriend she had – we always had to have a three-piece suite and dining table and chairs, however small the room. You could barely move. I couldn't breathe. Home was claustrophobic, not just emotionally but materially. So, as I grew up, I understood the idea of space. Indeed the fantasy of space. Decluttering must be a pasttime in its own right now for the hoarders of the lower orders. But, for other classes, the snobbery of emptiness or minimalism remains. Imagine no possessions… It's easy if you can afford anything you desire.

All of these mixed emotions surface when I see Grayson Perry's work. I loved my Mum, I hated our house; I couldn't wait for a room of my own, yet now I see how, though I escaped, so much of her remains with me. I see her social position against mine. I hate the word 'journey'; rather, these tapestries are a bracing walk through that taboo subject: class.

Foucault argued of sexuality that, while saying we are repressed, we talk of sex all the time. Similarly, we refuse a verbal discourse on class, except in our Marxist enclaves, but instead visually signal class difference, indeed class gradations, to each other all the time. Perry's TV series with Seneca Productions, *All in the*

Best Possible Taste with Grayson Perry (2012), was a blast of class consciousness, just when we are in deep denial about this reality. Of all the things I expected to come out of this series, the last would have been tapestries. Somehow this is perfect, though. Something old, something new; digitally produced by looms, *The Vanity of Small Differences* is arty *and* crafty. The tapestries use humour to depict loss and joy and a pervading sense of anxiety.

Above all, I see Perry as a profoundly moral artist, which may sound a slightly strange designation for a figure known chiefly by the headline-grabbing label, 'transvestite potter'. But these are deeply moral, indeed earnest, works – a mode which is, in itself, unfashionable. Irony, after all, is the default mode of so much contemporary culture. The opposite approach, I feel, is more productive. Aesthetics and ethics are related in complex ways, which make art less comforting than the art market as such would have us think.

By straightforwardly asking all kinds of people what they like and why, Perry used television to navigate a way through the class anxieties that plague us all. What if I don't fit in? What if I don't stand out enough? Perry teased out from his interviewees, completely without judgement, how we use taste as a way to signal the tribe we aspire to. What if objects really mean something, and that meaning is about more than materiality?

You can imply a fake past – the distressed leather sofas of the gastropub imply something heirloom-y. But what if something is so bad that it is not good but simply bad, and you have made a tasteless joke?

If identity is staked out through what we eat, how we dress, how we decorate our houses, we are all rather overwhelmed by choice.

Choice has now become oppressive. Rich people have interior designers make choices for them. A woman featured in the second episode of Perry's programme brought a show flat, already decorated, to avoid the dilemma. I have some sympathy. The exercising of 'individuality' is arduous. The tyranny of choice is too much. Who is not afraid of getting it wrong?

It wasn't always like this. It was easier to be different. Not every subculture was snapped up by *Vice* magazine while it was still foetal. Just the wearing of black – now my preferred, and unthinking, uniform – signified subversion. When I had my first child, a friend knitted a black baby jumper and bootees. My mother wept for the old pink and blue – I am surprised social services were not alerted. But then my mother never could cope with my 'taste'. When was I ever going to make something of myself, she asked, when I told her I had a column in *The Guardian*, a newspaper she had never heard of. It had been bad enough when I went out in a tutu and leather jacket and she uttered the immortal words, 'Ipswich is not ready for footless tights'. For it was so easy then to outrage – to wear a bin-liner, tooth brushes in our hair, kettles for handbags – and to play with the notion of what clothes were.

And how we played. This all came flooding back to me when I found myself at a party several years ago, actually discussing kitchen tiles. If this was not a mid-life crisis I don't know what is. Since when did I care about kitchen tiles? Or even kitchens? When did my house become me? My very soul? I am not what I eat, nor what I wallpaper. Microwave or Aga stove – who cares? The over-designing of everyday life had begun to feel as claustrophobic as my mother's living room.

Crucially, I remember how this all started to accelerate in the 1980s, when life in the Western world turned into 'lifestyle'.

We could blame it on Thatcherism, as we can most things; the massive political and cultural shift towards appealing to an aspirational working class; the realisation that this could be achieved through selling off council houses; the idea that greed would trickle down; that consumerism was the chief means of expression; that shopping was not a means to an end but an end in itself – all of this became real in that period.

The little people who had to buy their own furniture were suddenly confronted with rarefied concepts in design; I interviewed a booming Terence Conran at the time. People had been abroad and had seen how it could be. They would no longer bring back a flamenco doll from Majorca, as my mother had; they would be sold an imitation Mediterranean look, *sans soleil*. Mum came to visit me in my council flat in Kings Cross, London. 'Well, it might be all right when it's furnished,' she concluded. It was furnished. I just didn't have all the little ornaments that she considered necessary. Now I do, but they are 'ethnic' to indicate that I have travelled – that my mobility is not just social but global.

Class was becoming more than a theory to me, even though as a mature student I had studied Marxism. I started doing a PhD and always felt like I needed a bath before I met my supervisor. I felt this way when I went to work in newspapers – I was not of them, I knew not their secret codes. It was intimidating, until I realised that I had confused cleanliness with middle-class-ness, confidence with cleverness. I envied these people's certainty, but I despised what I perceived as their lack of joy and instinct.

Perry has instinct. He understands that working-class taste is about display and comfort and bling and play. Of course it is ridiculous, some of it. It is nasty and ostentatious at its worst, and as sentimental as we see in his depiction of it (*The Agony in the Car Park*, 2012, p. 69). But there is a generosity there – an ability to live in the moment. Getting ready to go out is as much fun as going out; in Sunderland, Perry played with the current aesthetic of the hyper-feminine (*The Adoration of the Cage Fighters*, 2012, p. 67).

So, too, his humanity stretches to the inherited sadness of the upper classes, who cannot live in the moment ever, only in the past, as they keep their crumbling gaffes alive in cold deprivation. The distressed look sought out by the upwardly mobile is actually distressing for this group. I was once helicoptered into a stately home (don't ask) and shown around. We were given the finest wines known to humanity, yet I was shivering with my coat on. No one remarked on my discomfort. I suppose it revealed my working-class weakness.

Discomfort, though, is exactly what Perry pinpoints most acutely in his depiction of the middle classes. This is, of course, where more and more of us claim to belong, but we are bewildered by the exact worth of our own cultural capital. French philosopher Pierre Bourdieu, from whose theory this notion comes, talks of disembodied cultural capital – things, books, art – and embodied capital – I am thinking here of fake tans and tattoos. He wrote too of how cultural capital is transmitted domestically and through inheritance, but primarily through education.

Post–Bourdieu, we read Susan Sontag's definition of camp – 'love of the unnatural: of artifice and exaggeration… esoteric – something of a private code, a badge of identity even, among small urban cliques' – and began to see postmodernism as camp for straight, middle-class people. Kitsch is fun but employed with a sneer. Any artist must ask, surely, 'What is beauty?' and I can't help asking, 'What are the politics of this visual style?' Style as a knowing wink that only a chosen few can understand

has become popularised. Its edginess has become marketable; this is no longer about playing with identity, but simply displaying one's expanded visual vocabulary. Camp, which is meant to be a way to survive, is commodified, becomes just another signifier of knowingness, no longer a radical aesthetic at all. The same thing happens to minimalism. 'You want to sell your house, love? Paint it white. Strip the floorboards,' says the estate agent. Make every bedroom look like a boutique hotel.

The reason this becomes problematic for the middle classes is because, as Perry points out, they are acutely self-conscious. 'No better than they ought to be,' as we used to say, though they do try. For class is embedded in culture and culture is ever-evolving – it contains what Raymond Williams identified as dominant (existing), residual and emergent elements. All of these are woven into Perry's tapestries: what was there; what should be there; what will be there. The cultural struggle is always over meaning. The middle class remains both unknown to itself and fearful that what is valuable may disappear. This sense of loss is mysterious but hangs over Perry's work.

For me, to read writers or to see artists who understand that working-class culture can be as profound and as complex as high culture remains exciting. Yet this is not to romanticise it; there was much I was glad to run away from. And where was I to run to? Is there a place where taste is democratic rather than just demographic? Is there a place where taste is about hope and morality and life itself; somehow not just a mirroring of market values?

I was very struck by Perry's reference to his key influence – Hogarth – who told us that his work was about 'the modern moral subject'. For this work is also about moral issues: the battles, both individual and collective, around consumerism – lived out as we reconfigure our own relationship to how we live and what we buy; the sadomasochist instinct that 'good taste' is perhaps just something I haven't bought conceptually or actually just don't understand. The knowledge economy is not a neutrally aesthetic enviroment – far from it. This is why education matters and why politics, a word Perry doesn't use but which is the subtext to this work, matters. A democracy of taste remains a thought experiment. For, while everyone has taste, some, we are taught, have more than others. Just as Hogarth dealt with lived experience and disappointment, Perry looks at the ethics beneath aesthetic choices.

At a time when social mobility has ground to a halt – when inequality booms and cannot be bust – Perry reminds us of how we tell each other who we are and who we belong to. In these conservative times, this is a radical thing to be doing. That is why this work is important. Sometimes things not only look good; they are good. I am making a moral judgment here, but then I recognise myself – my flaws, my dreams – in these tapestries of joy and despair, of ugliness and beauty.

As Perry has said, 'Taste is a tender subject. What really fascinates me about the topic of aesthetic taste is that people really care.' What really fascinates me about these works is precisely that they are really caring – and for those often not cared for. Classlessness is a dream. The very ability to accrue cultural capital, to make tender aesthetic choices, to shift class, as both Perry and I have managed somehow to do, is being taken away. Taste, like everything else, will be further privatised; we are not all in it together. These tapestries put the debate back in the public realm. Taste belongs to all of us. Make it your own. For this is how we live now.

Research

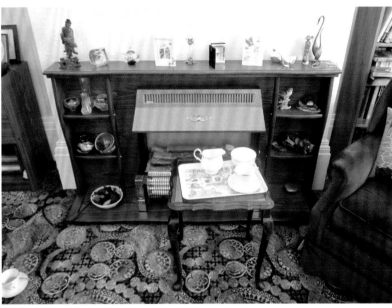

Older ladies' front rooms in Sunderland, full of pattern and clutter – this is the environment I grew up in. Has it affected my art? To the Ikea generation it looks like sentimental kitsch, unlikely to achieve 'vintage' status; to the owners, each piece evokes a personal memory. Photographs of 'the first in our family to go to university' are proudly displayed amongst the dancing trophies and best china.

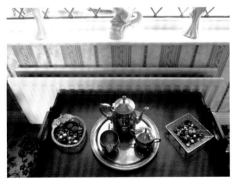

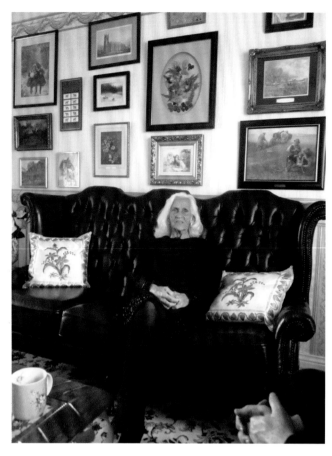

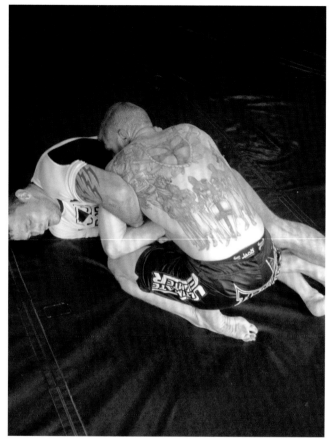

Edith Ramsey (above) sits amongst her treasures; her son Neville inherited her glamorous streak and became a very successful hairdresser.

'Ornament is crime' – so said early Modernist architect Adolf Loos in an essay published in 1910. The legacy of this statement has been hard to shake off, particularly amongst cool minimalists. Loos thought that a love of ornament, including decoration such as tattooing (top right), was 'degenerate'. The title of Loos' essay, 'Passion for smooth and precious surfaces', could describe the near-universal occurrence of a bowl of pebbles (far right), in every home of every class that we visited.

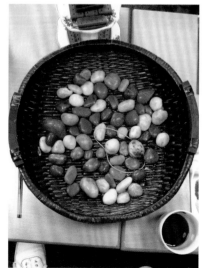

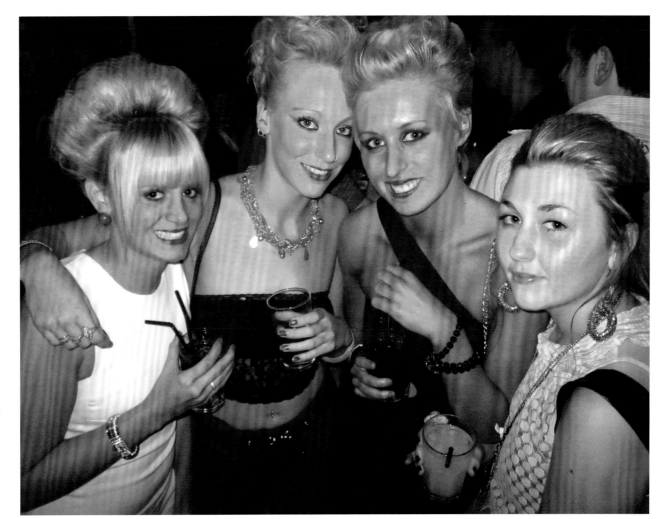

After ritualised grooming, which can take two days – clothes shopping, spray tanning, waxing, nails, hair and make-up – the night out begins with a 'pre-lash' at home, then on to Jägerbombs in city-centre bars. The base level of glamour in Sunderland on a Friday night would make an upper-class wedding in the Cotswolds look dowdy. These women invest heavily in social display.

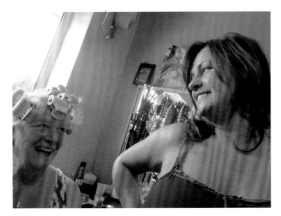

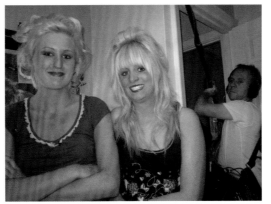

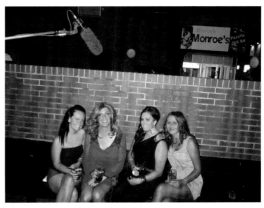

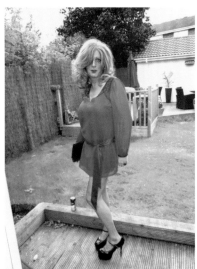

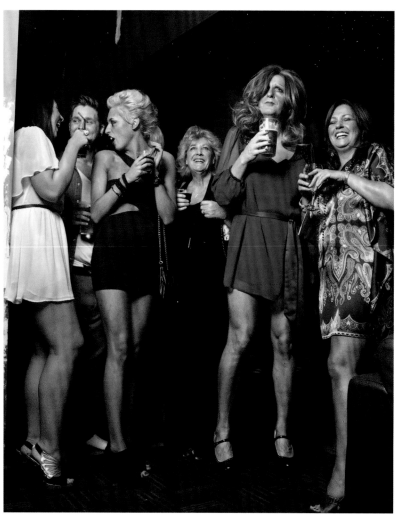

It spooked me a little when I noticed that I had dressed Tim Rakewell's mother (in *The Adoration of the Cage Fighters*, p. 67) and the nurse present at his death *(#Lamentation*, p. 77) in the same Madonna-blue dress as I wore on my night out in Sunderland. Such is the unconscious process of creativity.

Pink for girls, camouflage for boys; males often cloak their aesthetic choices as function. They love a skeuomorph – a design feature that used to be functional but that is now purely decorative. A man who puts two five-litre turbo-charged engines into a Renault Clio (left) understands this.

A pigeon cree does not have to look like a temple – like the one above, built by Maurice Surtees and his brother in the 1940s – but it helps when it becomes listed so as to safeguard the local allotments. Pigeon racing and custom cars, the changing face of working men's hobbies from the age of industry to the age of consumption.

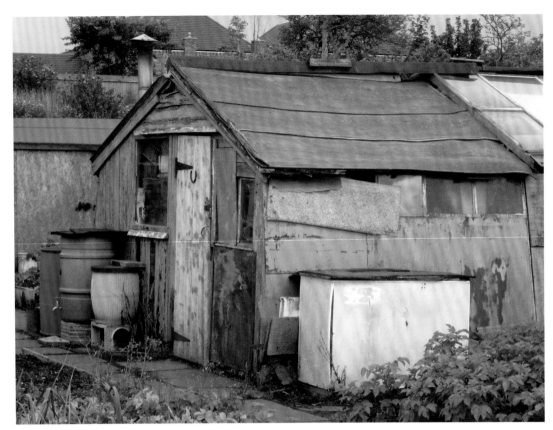

The shed aesthetic is an aspect of the working-class sublime. Sheds like the one shown above are austere homesteads, male wombs, oh, and somewhere to keep the tools.

My evening at 'Heppies' (the Hepworth and Grandage Social Club, bottom right) inspired *The Agony in the Car Park* (p. 69). Between the bingo and the meat raffle (top right), Sean Foster-Conley sang a song made famous in the club by his mother. As he sang, a friend of his mother's came to the stage, reached up and tearfully held his hand for the duration of the song. This scene was accompanied by the sight of a fat, tattooed man, naked to the waist, cavorting about the dance floor. It was at once moving and comical, and struck me as a demotic masterpiece.

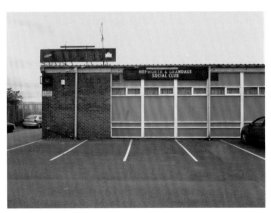

This is the view (left) from Jayne Newman's show flat on the King's Hill estate, as it features in *Expulsion from Number 8 Eden Close* (p. 71).

The carefully contrived architectural variety of this estate runs from flinted cottages and oast-houses to Victorian villas and Georgian terraces. Net curtains are frowned upon but fake grass (above) is an option for your lawn.

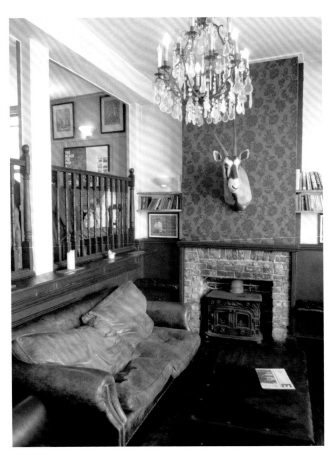

In the consumer paradise, even eclecticism is prescribed. A pre-scuffed sofa, a 'feature wall', 'ironic' chandeliers and a hunting trophy; the now fixed visual language of the gastropub and boutique hotel (left). Real kitsch is hidden away in a cupboard (below).

Pictured in her perfectly co-ordinated 'gilver' (her patented mix of gold and silver) sitting room, Kate Pinnel (bottom left) describes her taste as 'shabby chic'. All is calm and sleek, in neutral tones, with a more vibrant accent colour added. The owner of the kitchen shown opposite (bottom right) told me 'the work surfaces are recycled chemistry benches'.

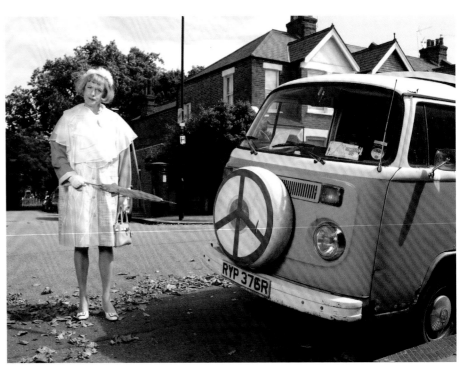

Allotments are now so fashionable they warrant a high-street concession (top left); eco hippies have become classic retro.

Su and Norman Collings (above) have lived in the same house in Tunbridge Wells for fifty years.

As one accrues cultural capital, one learns to mix and match with insouciance – a cheap knick-knack from TK Maxx (right) sits comfortably on an elegant cream mantelpiece.

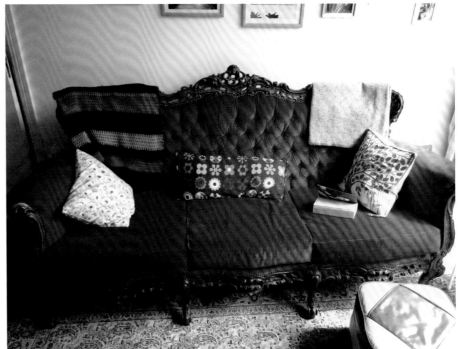

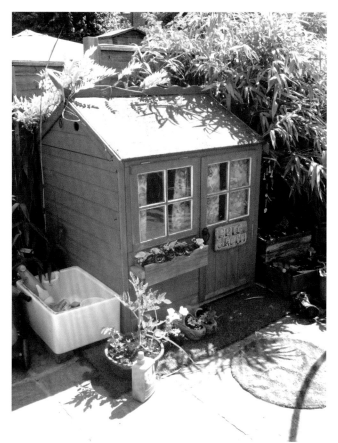

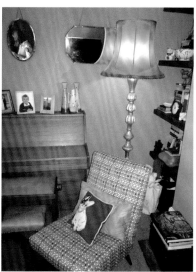

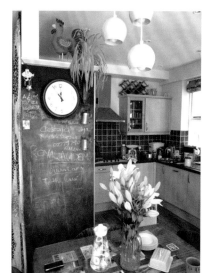

Vintage clutter says, 'I have a very individual style, I make these things more beautiful by association'. More than any other place I visited, Amanda Vokes' home inspired *The Annunciation of the Virgin Deal* (p. 73). Her confident combination of mid-century, kitsch, classic and ethnic styles exemplified the acute visual literacy of the 'Bobo' (bourgeois bohemian). Her children had the most tasteful Wendy house in the Home Counties and I coveted her red sofa (opposite).

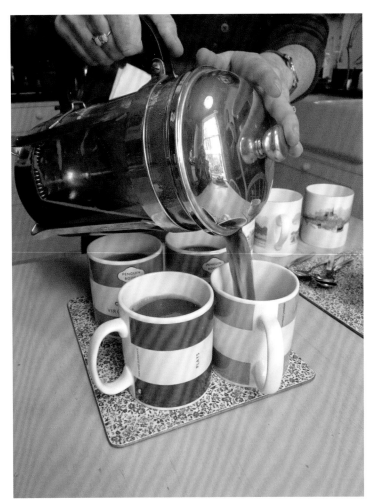

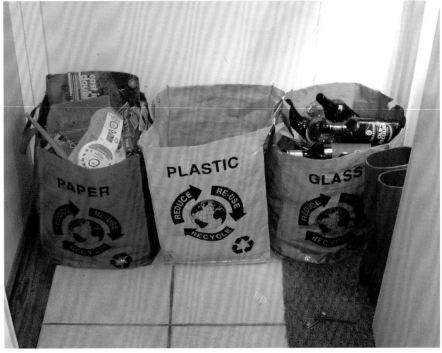

The cafetière (above) still retains a hint of continental sophistication; it is the chalice of the middle classes. The Penguin mugs allude to that other sacrament of cultural respectability – books.

To recycle, meanwhile, is to pay holy penance for the guilt of material success.

The Aga stove (right) is a fuel-guzzling eco hazard, but also an altar glowing with the authenticity of an un-renovated farmhouse.

Chavenage House, Tetbury (sign below) – available for weddings, film shoots and corporate events.

Frampton Court, Frampton-on-Severn (top right) – a mellow, golden time-capsule, hideously expensive to maintain, so now an exquisite B&B.

Janie Clifford's Grade II-listed Morris Traveller (bottom right). Note the Silver Cross pram and vintage sledges also in the garage.

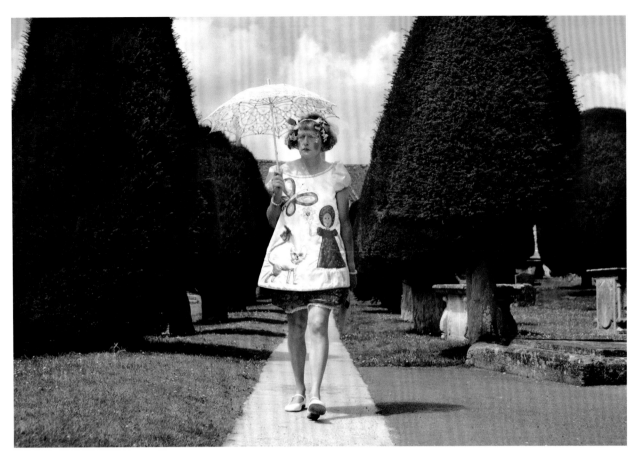

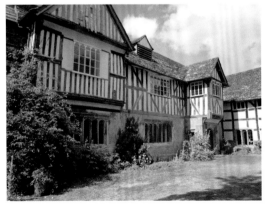

Me in Painswick churchyard (above) – the upper classes have always had a soft spot for a bohemian 'character'.

Below left you can see Owlpen Manor, Dursley – home to hoarders of the highest order. Frampton Manor, to the right, melts into Gloucestershire like a sugar cube on a silver teaspoon.

This chair is in the private apartment of John Berkeley, the man who owns Berkeley Castle and a large chunk of the surrounding Gloucestershire countryside. I understand that twelfth-century fortresses are expensive to run, but I'm pretty sure he could afford a new loose cover if he wanted one. He also has a four-poster bed that has been identified as the piece of furniture in longest continuous use by the same family in the UK.

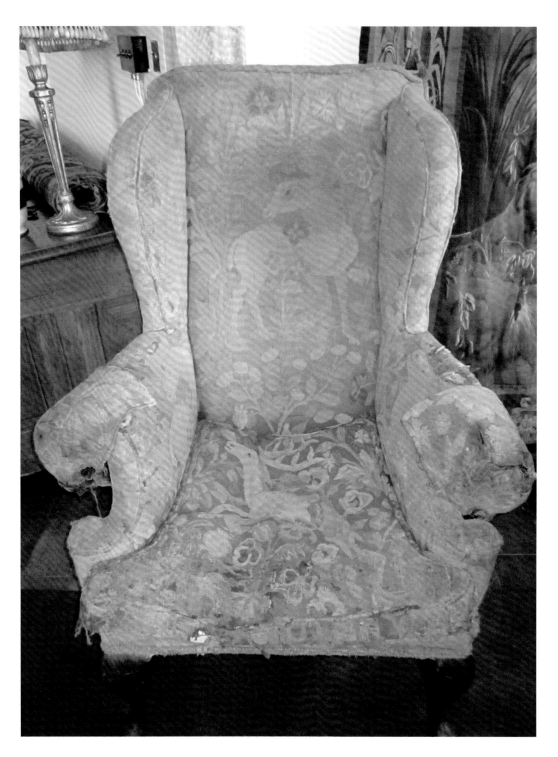

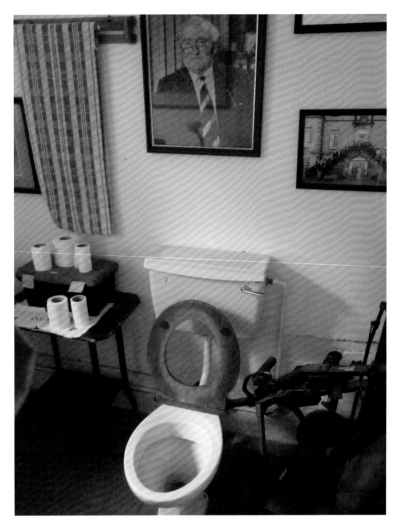

Hunting imagery (below) is everywhere in the upper-class home; horses and hounds are the default motif of the aristocracy. It was not difficult to decide how to depict them in my tapestry *The Upper Class at Bay* (p. 75).

Elsewhere, ancestors stare down, reproaching their heirs for even thinking of selling the family seat.

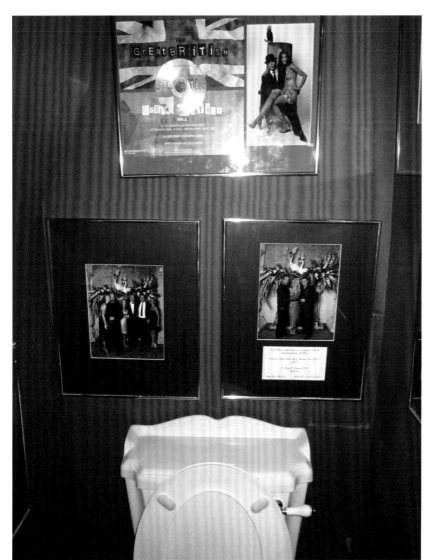

The lavatory is the place to find what anthropologist Kate Fox calls 'the bragging wall'. In England, boasting has to be done surreptitiously – by hanging any maps of the estate, degree certificates, portraits of oneself as chairman of the board, gold discs or photos with celebrity friends in the loo (above), one can seem not to be taking oneself too seriously and, at the same time, guarantee that every visitor will notice your achievements.

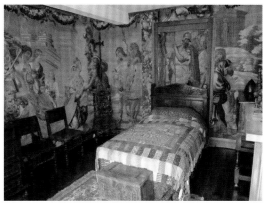

Nothing is allowed to change: tapestry-lined rooms at Chavenage House (above) remain as they were when Oliver Cromwell came to stay; an Aga at Owlpen Manor grows a crust (left).

An English gentleman loves his dog, his wife and his acres; Thomas Gainsborough's *Mr and Mrs Andrews* (below left, c. 1750) advertise their credentials as landed gentry.

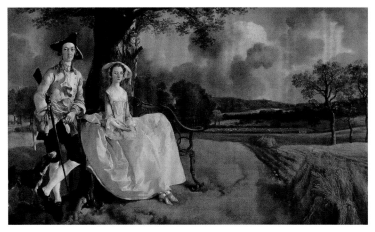

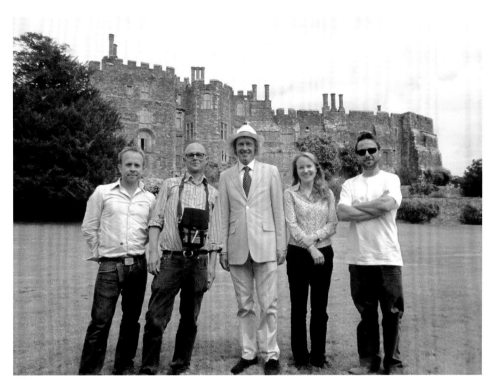

When I asked John Berkeley if I looked upper class he replied, 'You look very smart'. That's a 'no', then.

Here I am with some of the *All in the Best Possible Taste* team at Berkeley Castle, Gloucstershire: from left to right, Adam Scourfield (sound), Neil Crombie (Director), Emily Jeal (Assistant Producer) and Louis Caulfield (camera).

Sketchbooks

lower middle
in between place
hinterland Identity

free

Weird walk
counching on snails
in three grey petrol stations
two pub restaurants in a
mile very few horses

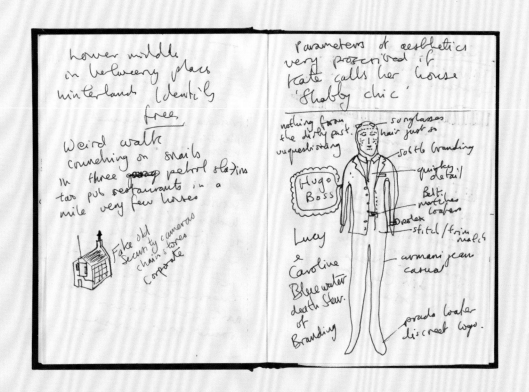

Fake old
security cameras
chain stores
Corporate

Parameters of aesthetics
very proscribed if
Kate calls her house
'Shabby chic'

nothing from sunglasses
the dirty past. hair just so
unquestioning

 soft branding
Hugo quirky detail
Boss
 Belt
 matches
 loafers
Lucy Rolex
 stitch/trim male?
&
Caroline armani jean
Bluewater casual
death Star.
of
Branding prada loafer
 discreet logo.

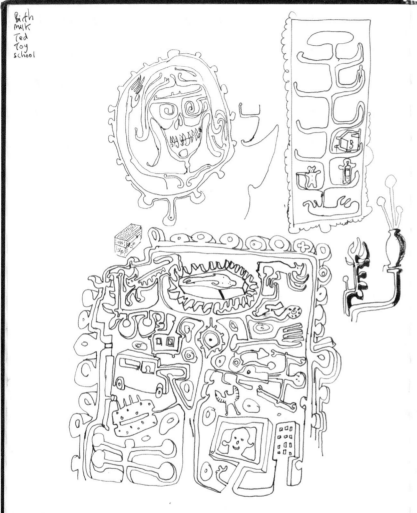

Visual notes for tapestries show neil v early ideas.
Colour swatches / pattern motifs / brand labels
Pose subjects in painting styles

Does it take several
generations to be accepted
by new class?
Take landscapes.
As an artist my 1st
responsibility is to a good
image...

Scarification.

dabby = rain.

Unnamed Road

Is it possible to
become upper class

Family frog antlers

Fruit tree

Car Boot Sale organised
commercial Tent
hearing the posh flag

Taste as a luxury
The idea of choosing
can seem a luxury....
a novel even unknown
experience unknown
patterned carpet
pot plants

- Umesh & Damini
 Tripura + Lokesh
 F ———— ⊙—●
 Outside of English Class
 System

Ophelia Balls.
the W/c would be carry over
tribal ritual of w/c feminity if
was happening in the 3rd World

WORKING 1 +2. Sunderland.

LOWRY. | Tattoos | Community | New shiny Bright Glam

Ghost of Old Industry | PORTRAIT.

Mona Lisa | Madonna.

Allotments. | Wrestlers at nativity? | HOT CARS

Nan's Front room knick knacks | FOOTBALL
ornaments as exemplify w/c culture

SENTIMENTALITY | "DESTINY" | HEPPIES

Altar piece of the club singer

Rock + Roll outsiders the expulsion Adam + Eve.

coloured Pigeon + cree | Ramped up feeling + glamour to punch through hardship

No escaping less money

Education as escape from what?

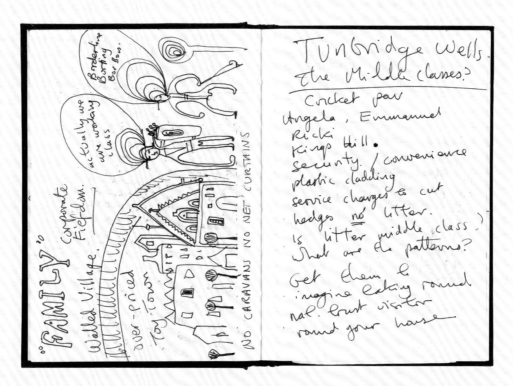

"FAMILY"
Corporate Fiefdom.
Walled Village.
over-priced Toy Town

actually we are working class

Borderline Boring Bor Bor

(NO CARAVANS NO NET CURTAINS)

Tunbridge Wells the Middle classes?

Cricket pav
Angela, Emmanuel
Ricki Hill
Kings Hill.
security / convenience
plastic cladding
service charges to cut
hedges no litter.
Is litter middle class?
What are the patterns?

Get them to imagine eating round nat. trust visitor round your house

Are MC trying to blame WC for consumerism?

'Must have

Mating

instinct

Consumption

WC taste closer to bare mating instincts faking okay. not eclipsed by culture.
Culture = restraint.

Does being financially impoverished mean being aesthetically impoverished. is 'Taste' middle class

PENNYWELL

YES!

ornaments from all aspects of W/C culture.

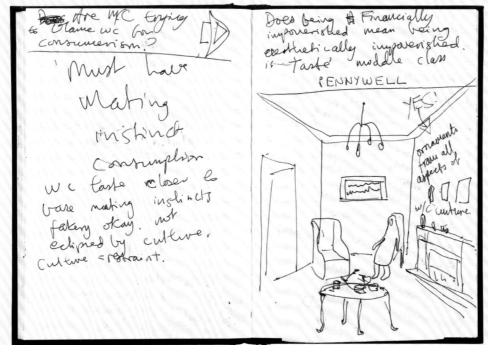

53

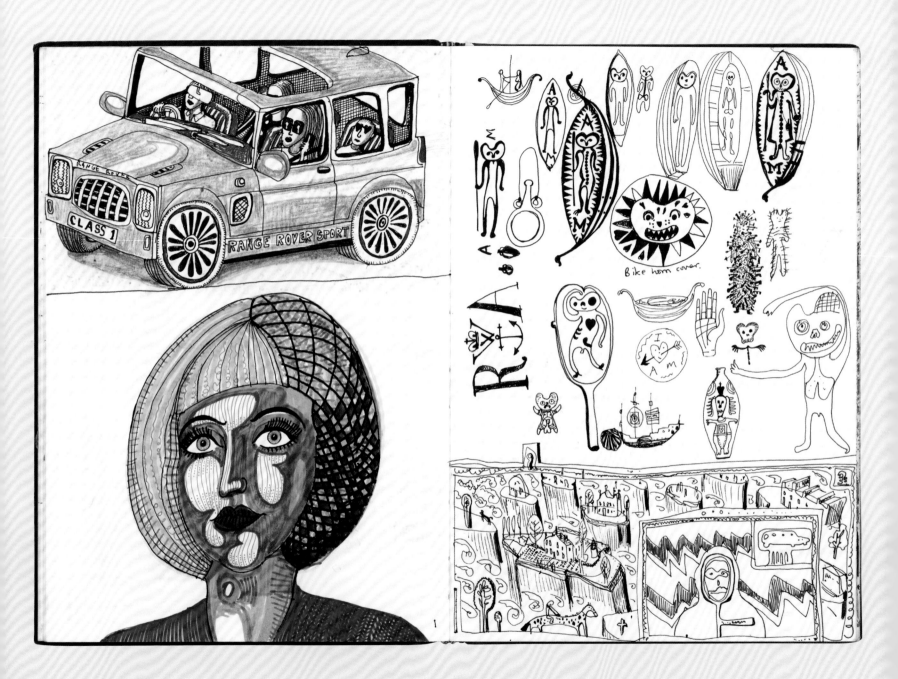

Bike horn cover.

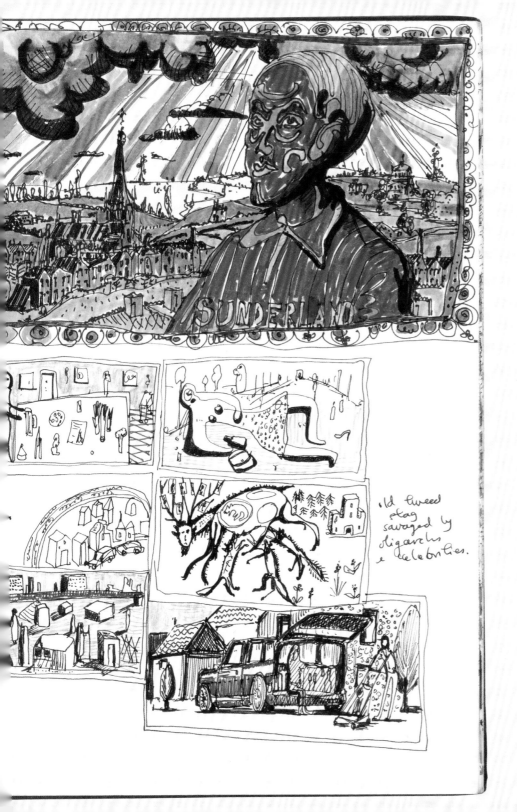

SUNDERLAND

old tweed
stag
savaged by
oligarchs
e celebrities.

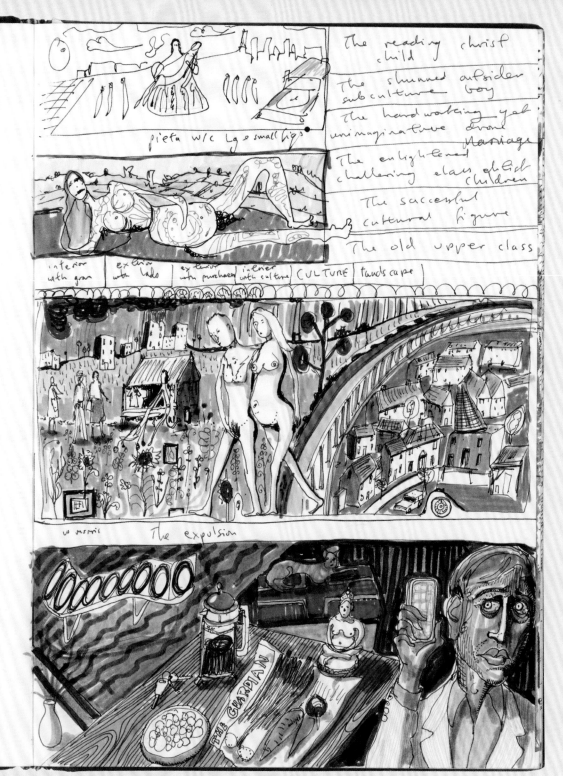

The reading christ
child

The shunned outsider
subculture boy

The hardworking yet
unimaginative drone

Marriage

The enlightened
challenging class ahead
children

The successful
cultural figure

The old upper class

pieta w/c Lge & small figs

interior with gran | exterior with lads | exterior with purchases | interior with culture | CULTURE | landscape

Clothes of
Adam & Eve
nude colour +
white?

The expulsion

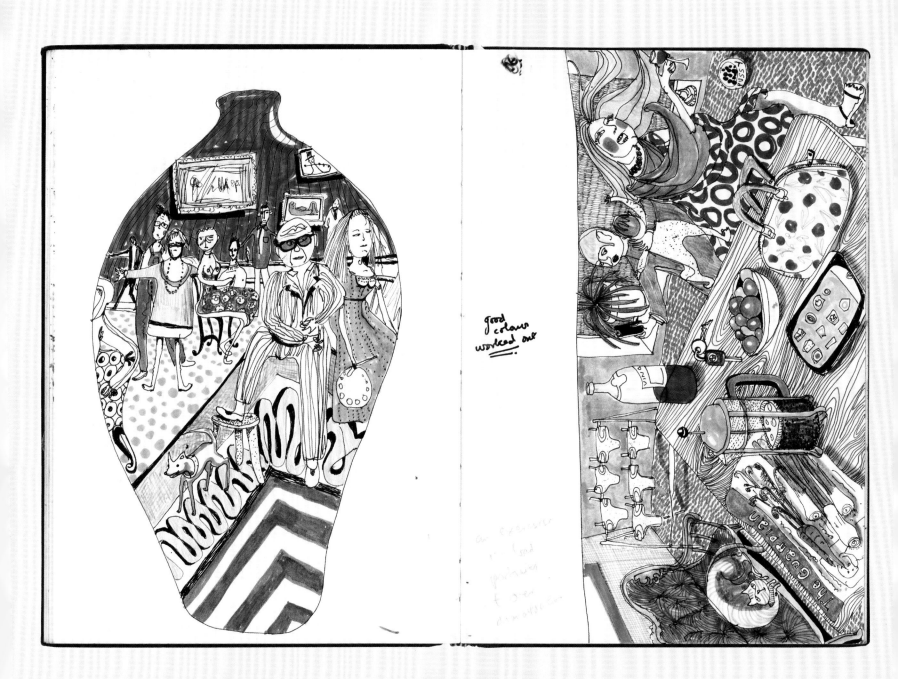

good colour
worked out
.

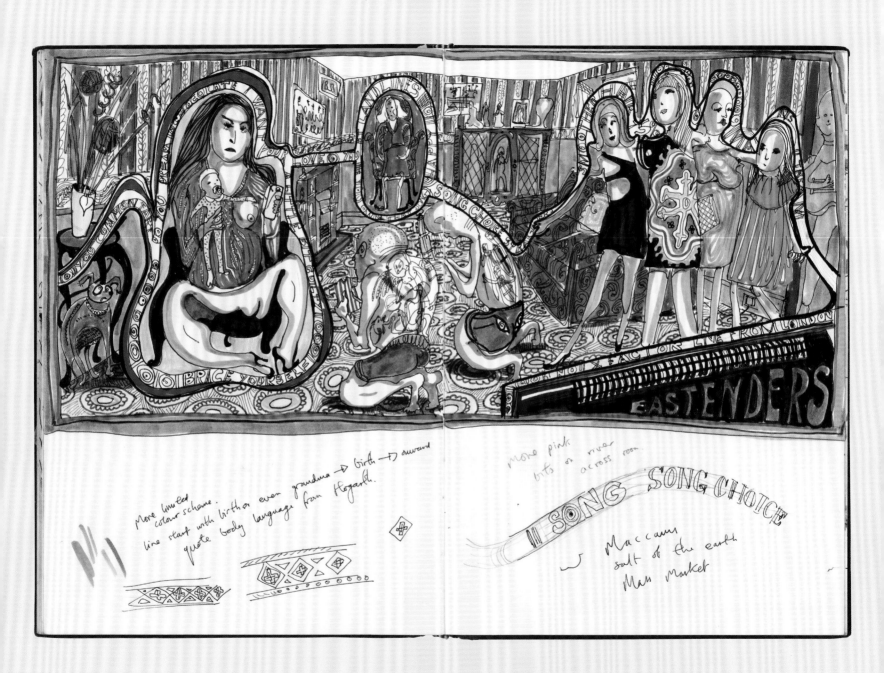

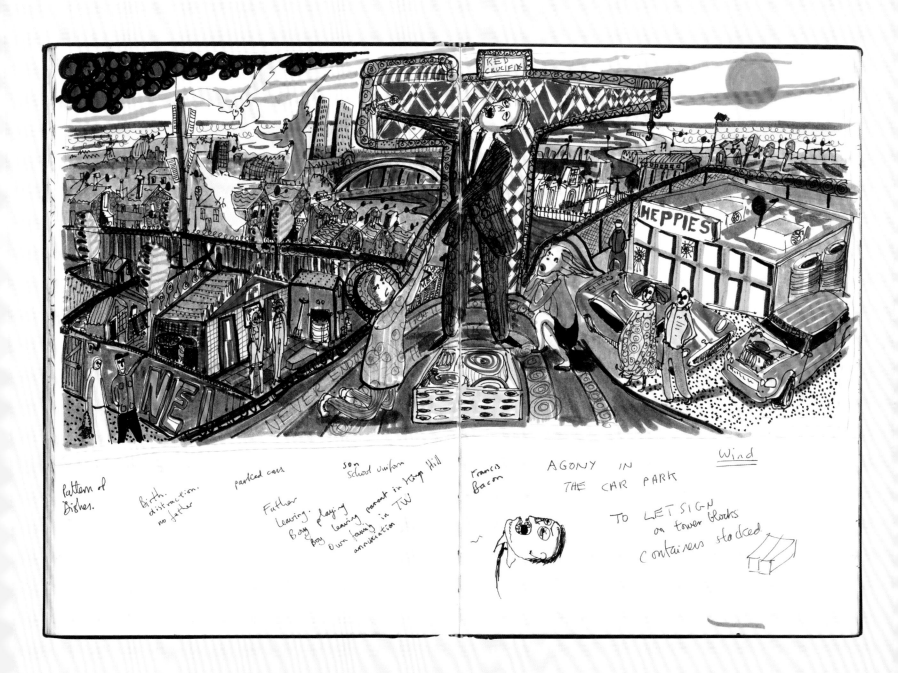

Jamie cook book
illustration

Youth cults
looking back
Which couple
pregger?

parents

Map one instead of second
v/c

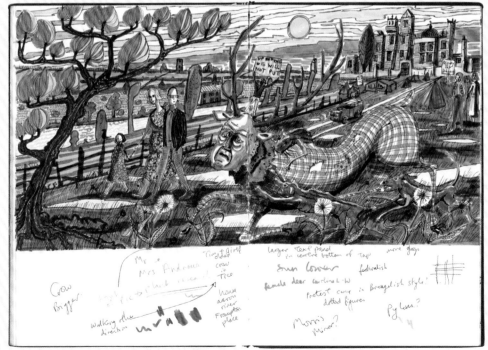

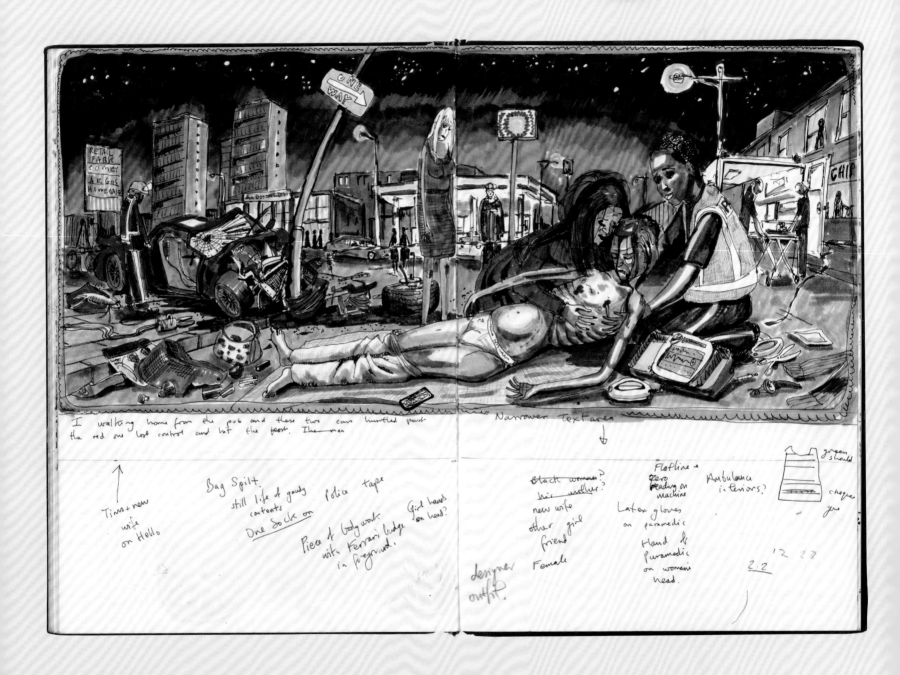

Plates

The Adoration of
the Cage Fighters

The scene is Tim's great-grandmother's front room. The infant Tim reaches for his mother's smartphone – his rival for her attention. She is dressed up, ready for a night out with her four friends, who have perhaps already 'been on the pre-lash'. Two 'Mixed Martial Arts' enthusiasts present icons of tribal identity to the infant: a Sunderland A.F.C. football shirt and a miner's lamp. In the manner of early Christian painting, Tim appears a second time in the work: on the stairs, as a four-year-old, facing another evening alone in front of a screen. Although this series of images developed very organically, with little consistent method, the religious reference was here from the start: I hear the echo of paintings such as Andrea Mantegna's *The Adoration of the Shepherds* (c. 1450).

Text (*in the voice of Tim's Mother*):

'I could have gone to Uni, but I did the best I could, considering his father upped and left. He (Tim) was always a clever little boy, he knows how to wind me up. My mother liked a drink, my father liked one too. Ex miner a real man, open with his love, and his anger. My Nan though is the salt of the earth, the boy loves her. She spent her whole life looking after others. There are no jobs round here anymore, just the gym and the football. A normal family, a divorce or two, mental illness, addiction, domestic violence… the usual thing… My friends they keep me sane… take me out… listen… a night out of the weekend in town is a precious ritual.'

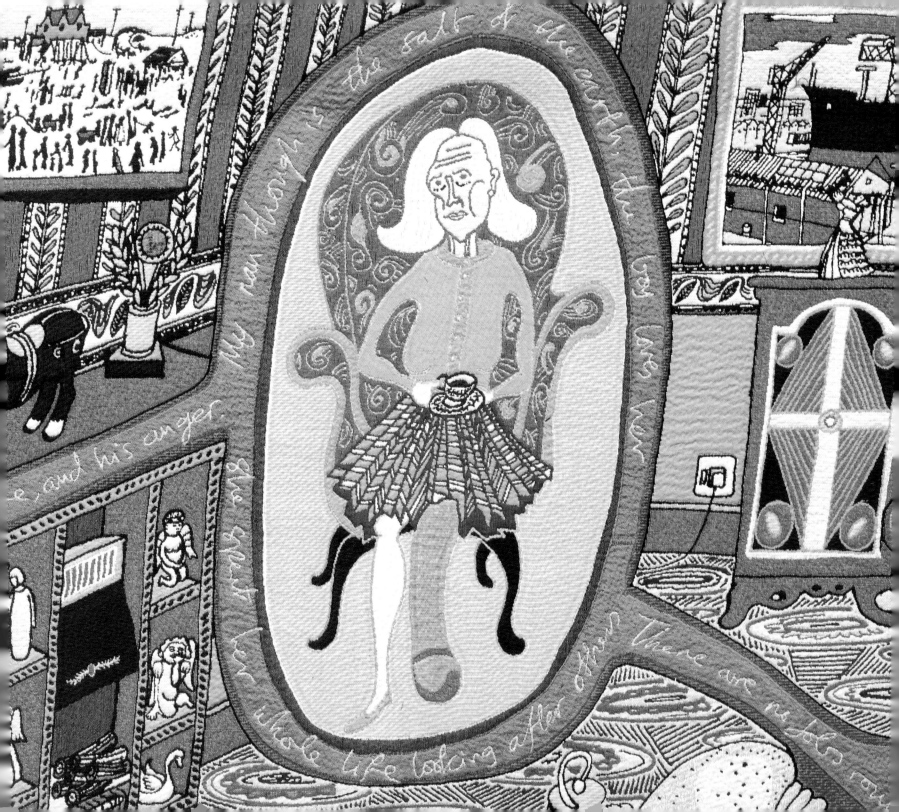

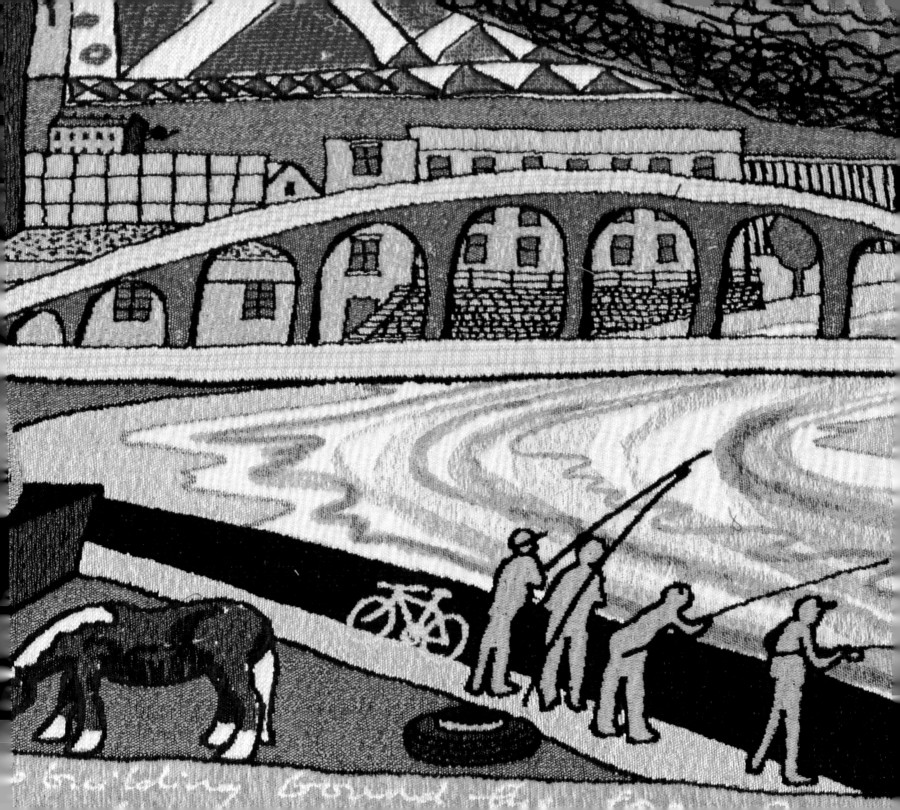

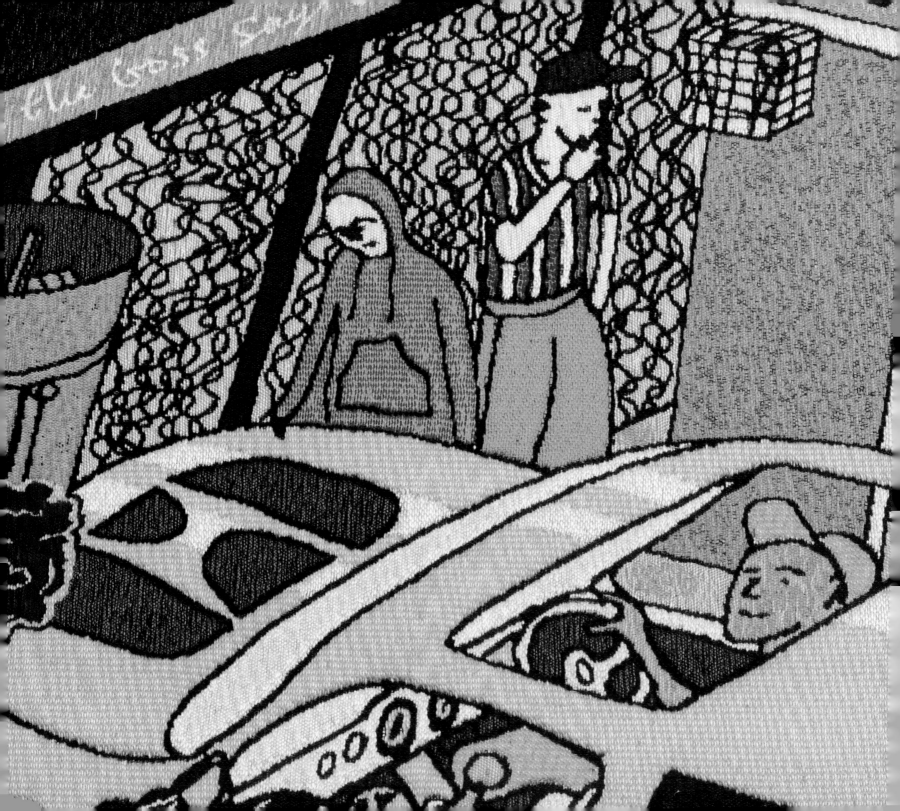

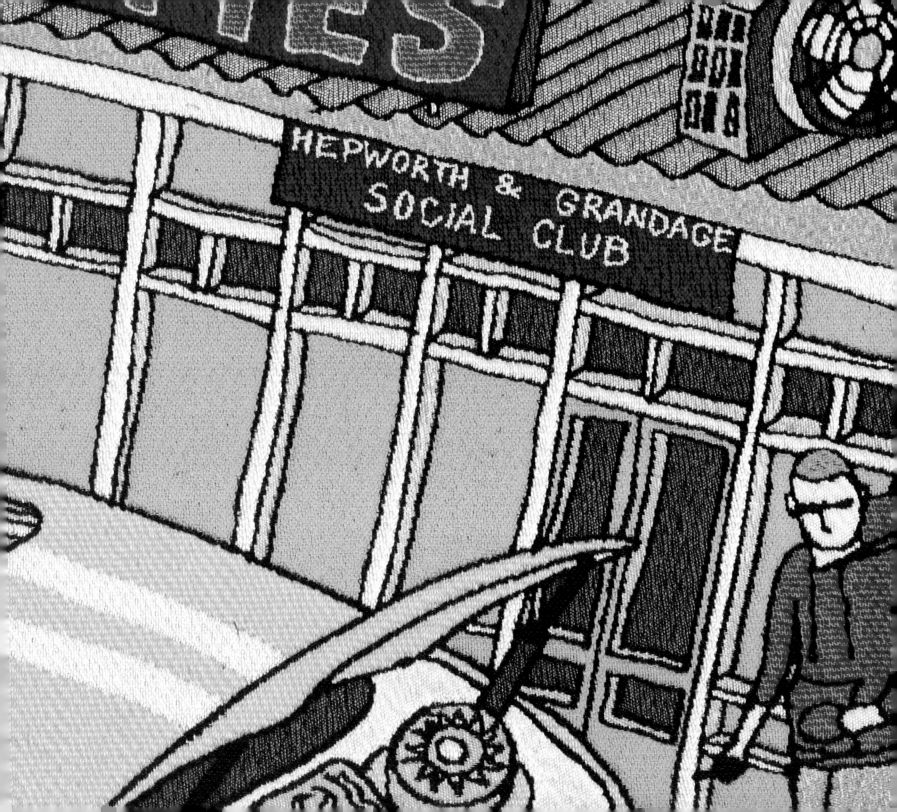

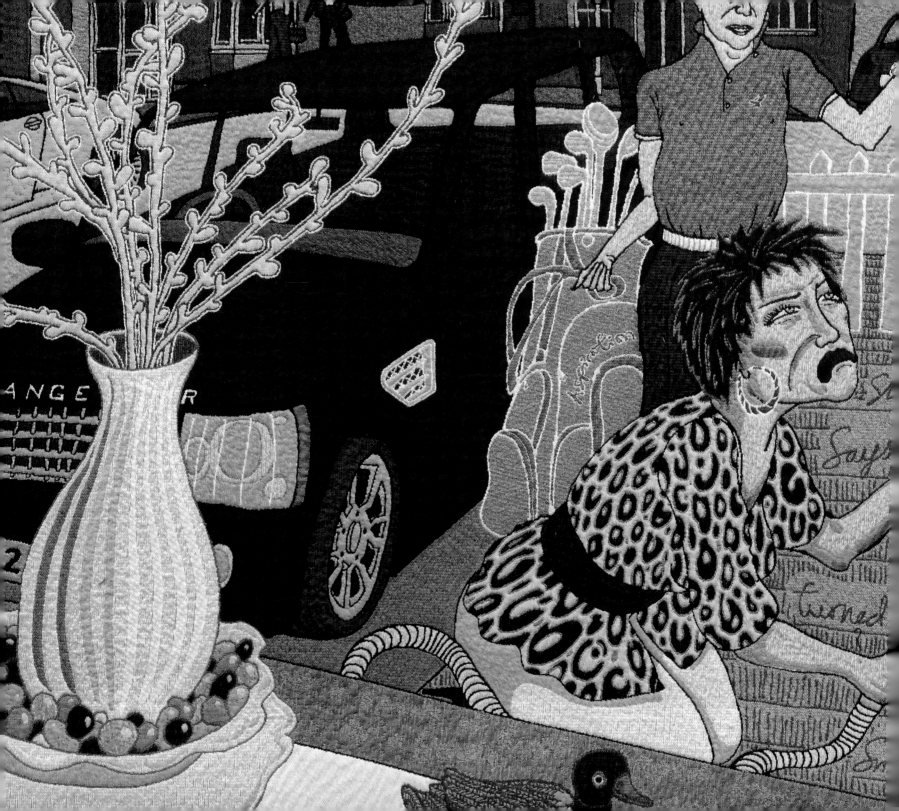

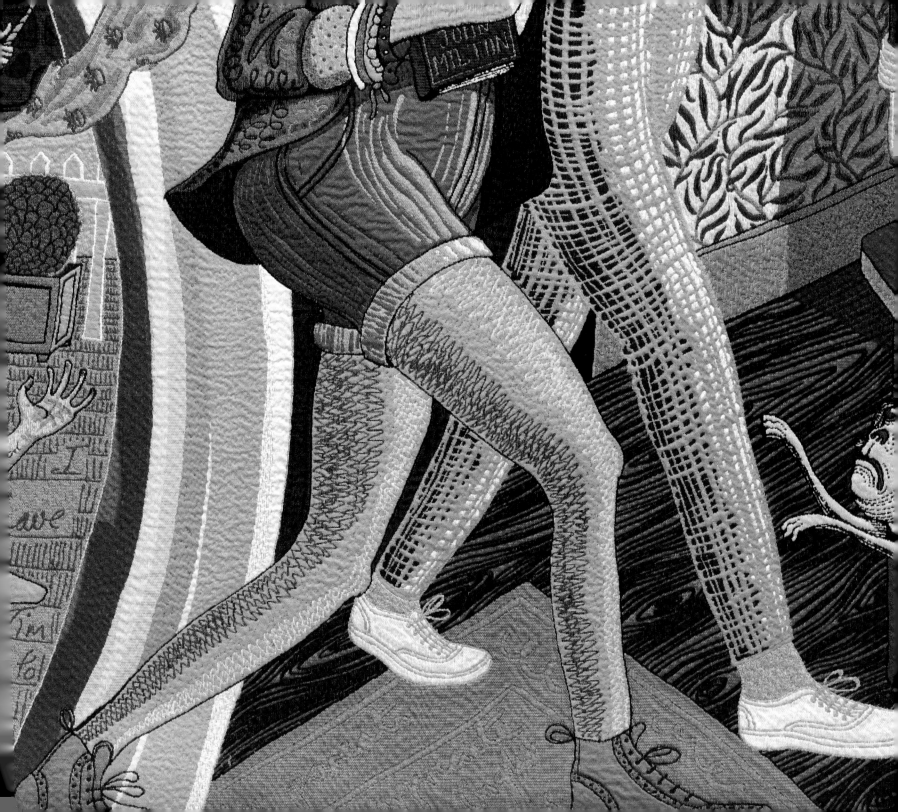

KNOWING
LAUGHTER
BY
EWAN NONYEW

CLAS
TRAIT
BY
CHIP E.

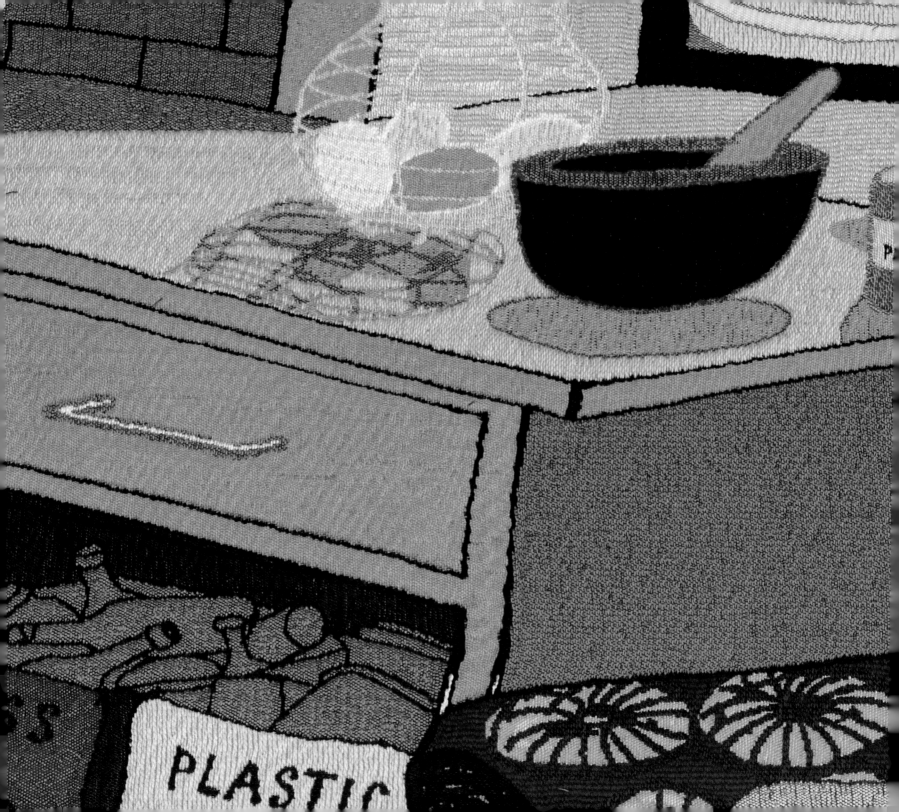

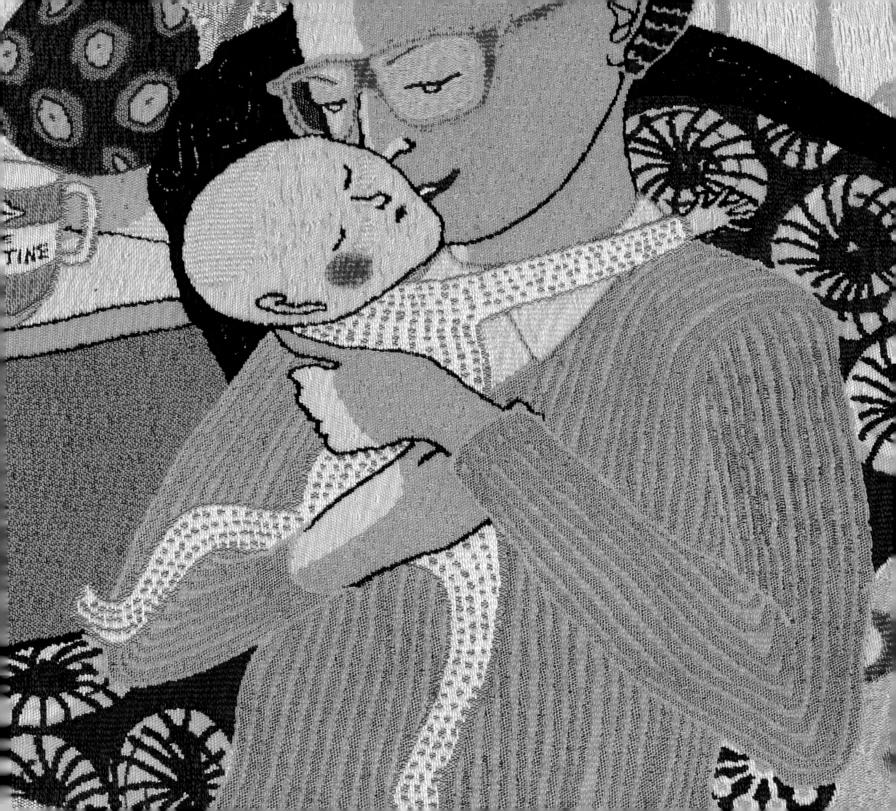

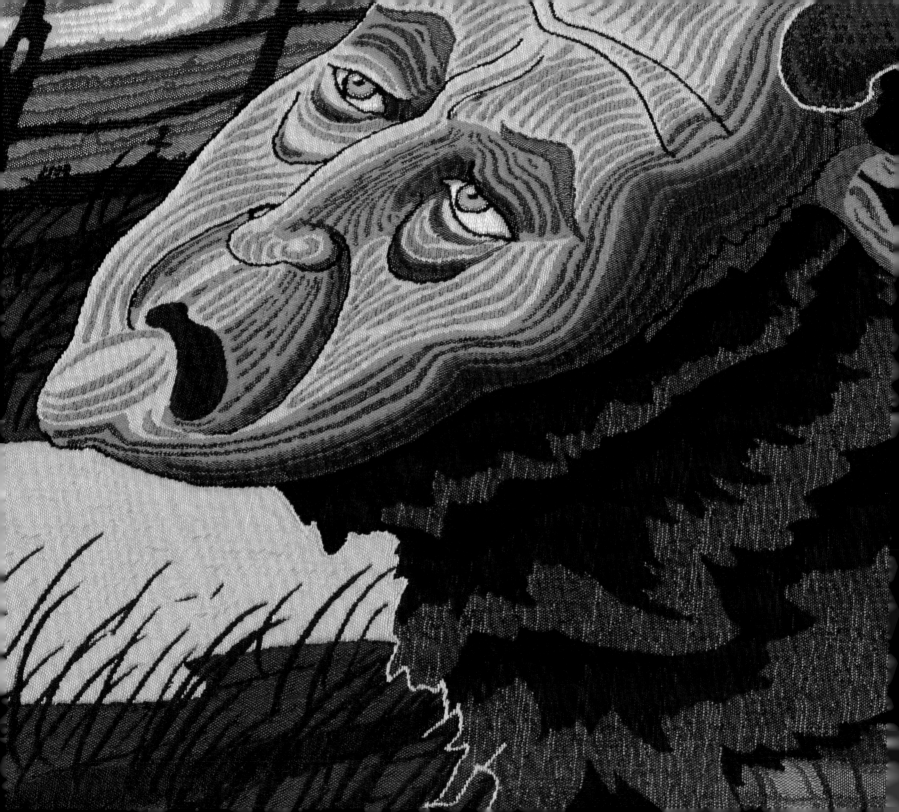

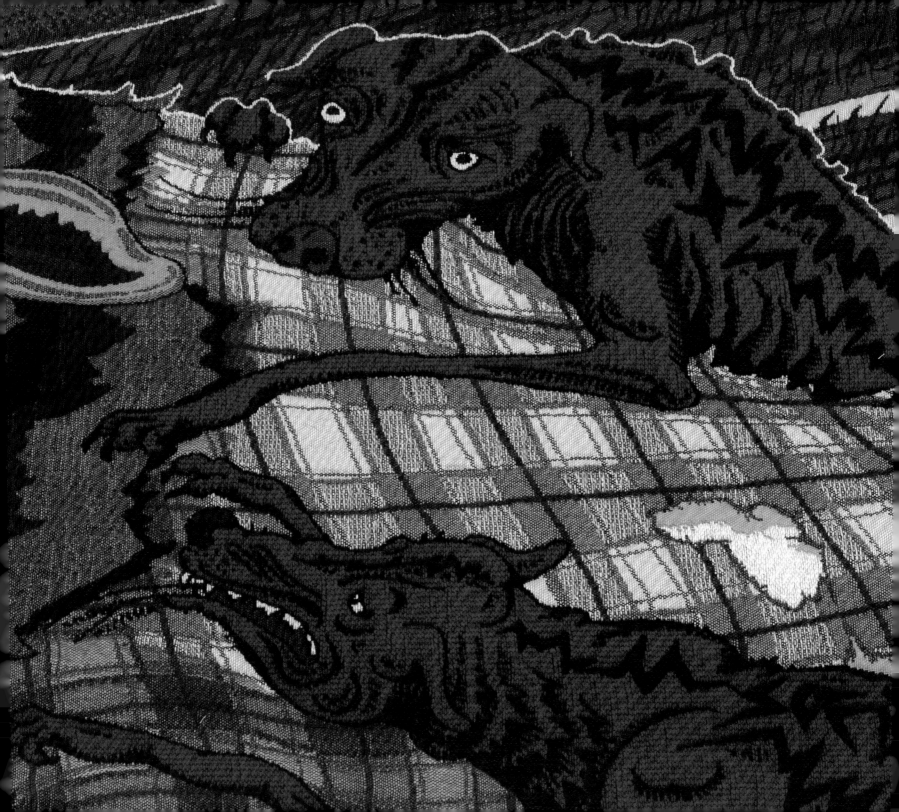

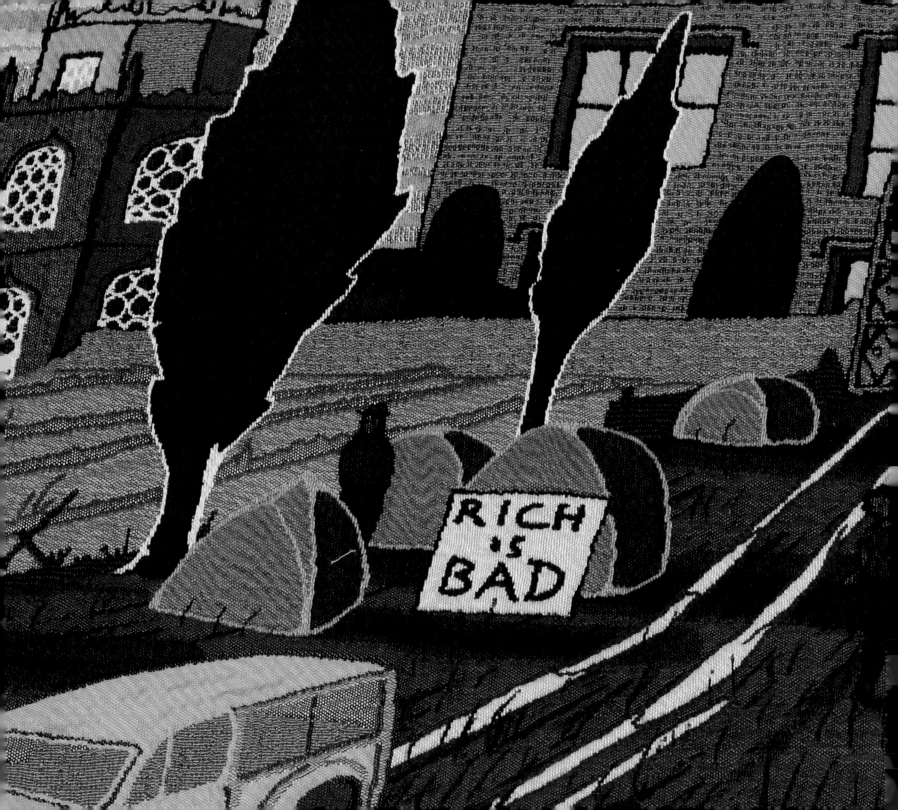

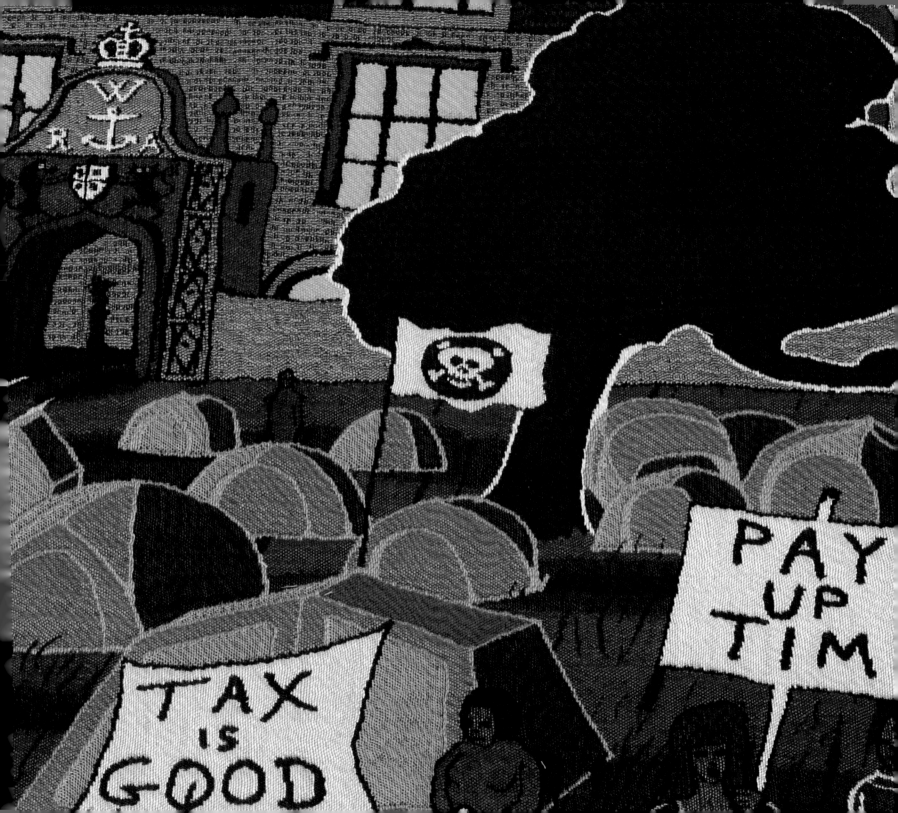

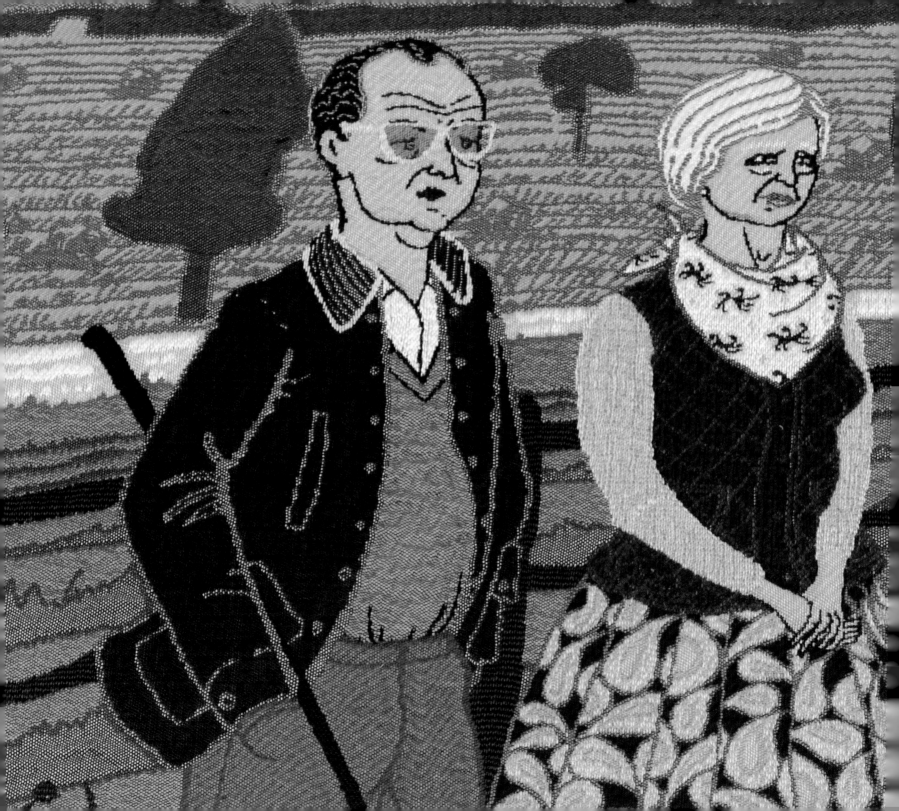

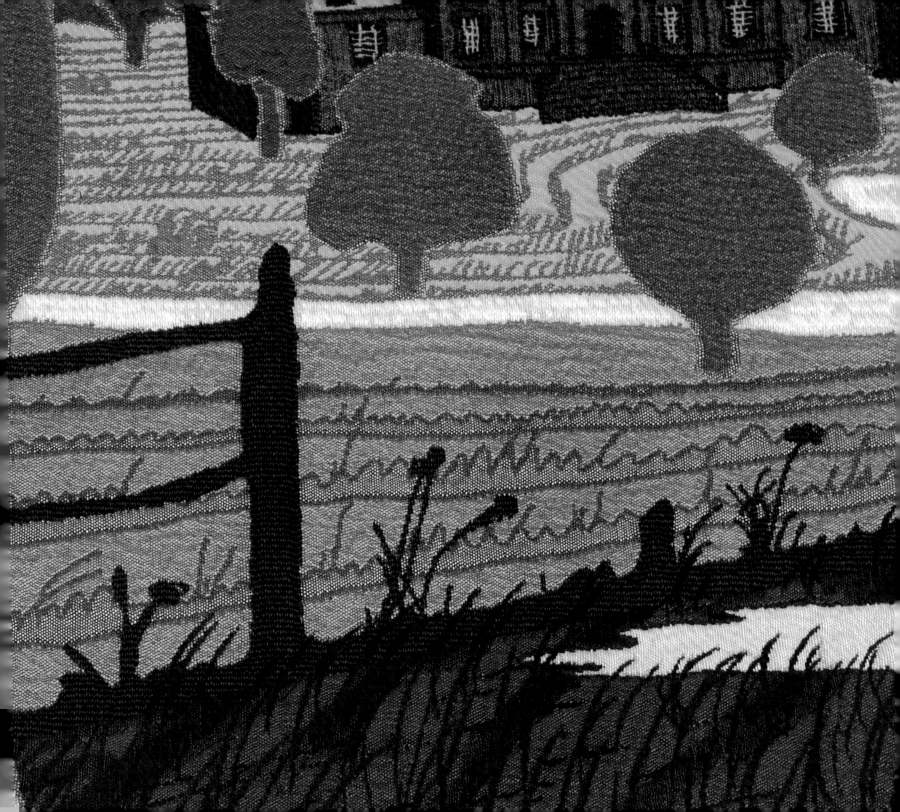

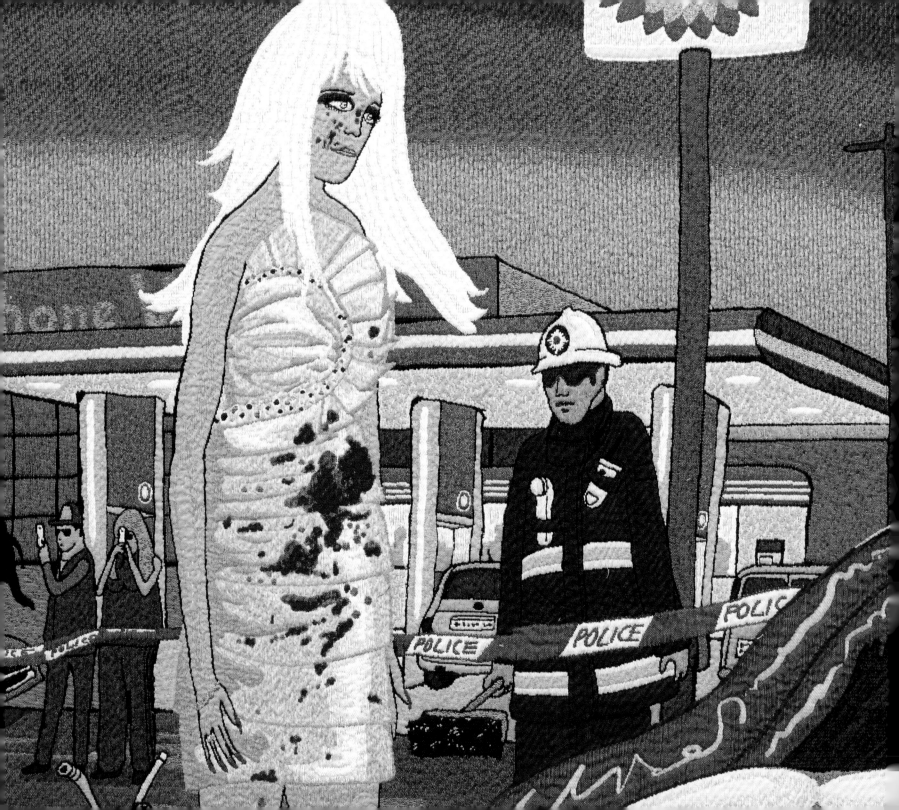

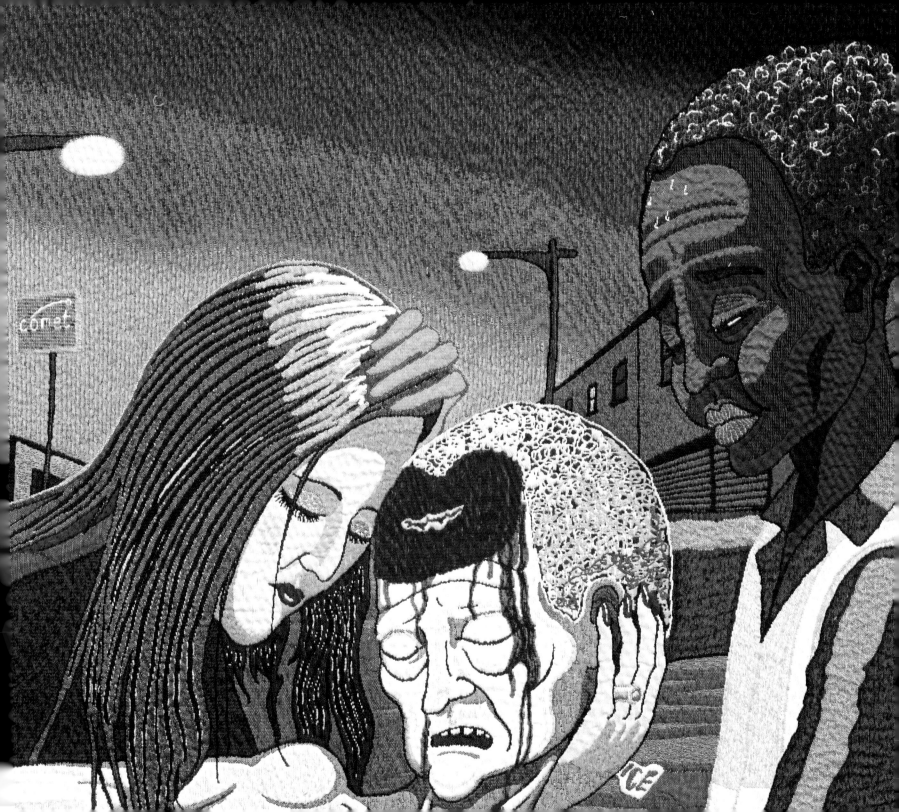

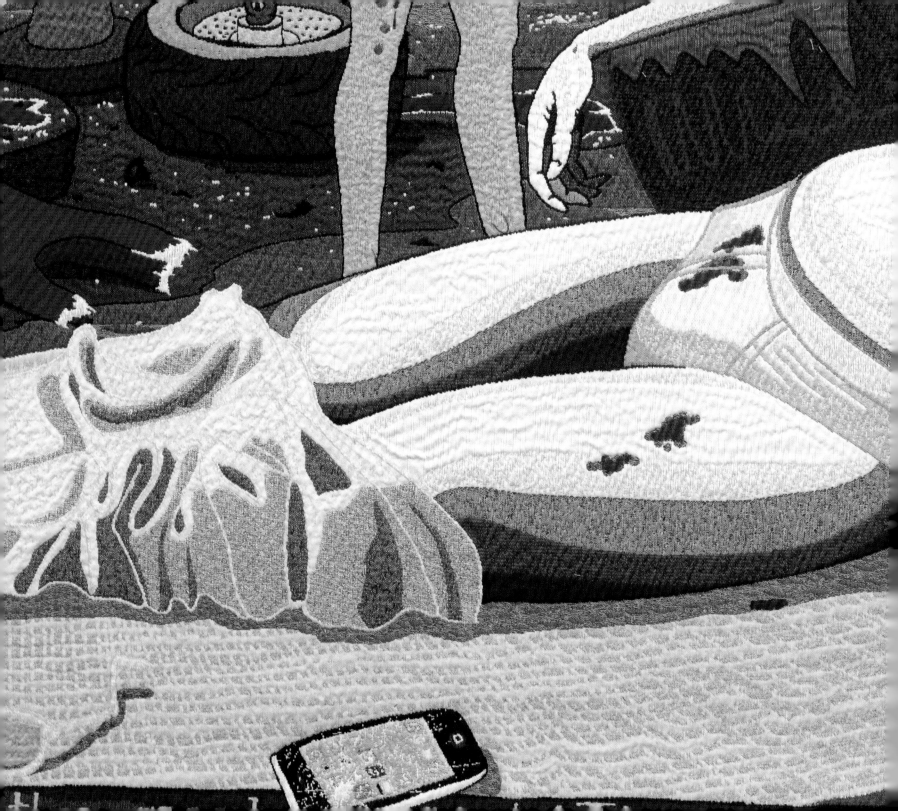

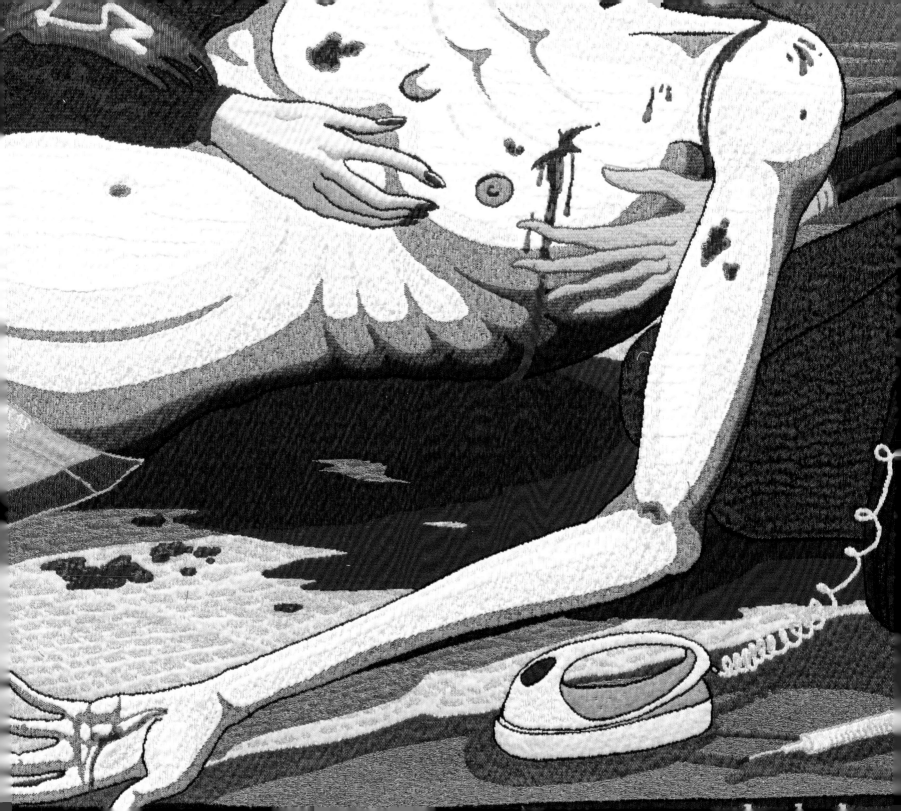

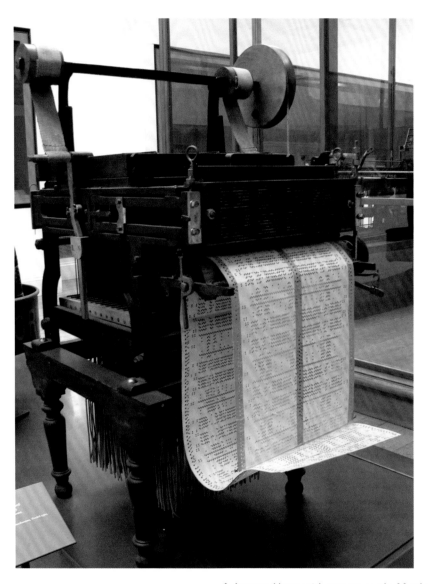

A Jacquard loom with pattern cards, Musée des Arts et Métiers, Paris.

Tapestry Decoded
ADAM LOWE

At the beginning of the nineteenth century, Joseph-Marie Jacquard, a Republican from Lyon, France, invented a mechanical loom that used punched cards to control the weaving of a design. The 'programmed' perforations in these cards controlled the movement of hooks manipulating the warp (lengthwise or longitudinal) threads of the tapestry. These cards formed a chain that was inserted into the loom, allowing some hooks to pass through the punched holes and therefore determining the movement of the warp threads. When one row was finished, the next chain of cards was inserted, and so on until the weaving was complete. It was an extraordinary invention, resulting in an unimaginable level of standardisation and speed. Unfortunately, not everyone approved of this mechanisation of the craft: some local weavers removed their wooden clogs and attacked the machines, thus coining the word 'saboteur' (from the French *sabot*, for clogs). Napoleon approved, however, and decreed the loom public property. Jacquard made the prototype in 1804; by 1812, there were 11,000 looms in operation in France.

Throughout the century, programming and refinements to the system were prolific. By 1886/87 a small prayer-book was being woven in grey and black silks on a Jacquard loom in Lyon. The *Livre de Prières Tissé d'après les enluminures des manuscrits du XIVe au XVIe siècle* (published by A. Roux, designed by R. P. J. Hervier and woven by J. A. Henry) was woven from an estimated 500,000 handmade cards. The resolution is such that every letter appears as if it was typeset, and the images have a tonal range that gives them the appearance of daguerreotype plates.

Perhaps more importantly, the English mathematician Charles Babbage saw one of Jacquard's looms and realised that it could be used to perform automated mathematical calculations. It was as a direct result of his encounter with the Jacquard loom that he developed his first calculating engine. Babbage's collaborator was Ada Lovelace (the daughter of Lord Byron). In 1843 she wrote: 'Thus, not only the mental and the material, but the theoretical and the practical in the mathematical world, are brought into more intimate and effective connection with each other – we may say most aptly, that the Analytical Engine weaves algebraic patterns just as the Jacquard-loom weaves flowers and leaves.'[1]

With the rapid development of computing technology over the past forty years the Jacquard loom has found a new purpose – for the output of images either made or manipulated in a virtual space. Grayson Perry is an artist who has recently taken up the challenge this offers.

Perry's first work in this medium, *The Walthamstow Tapestry* (2009, Paragon Press), draws on the medieval morality tradition popularised by early Flemish weaving workshops in centres such as Arras and Tournai. Within the ostensible subject of the seven ages of man, the narrative potential of the Bayeux tapestry and Christian iconography collide with autobiography and confession, in a simultaneous celebration and critique of the modern icons of capitalist consumer society.

The source material for this work was derived from scanned sections of Perry's line drawings. These had been drawn by hand and then manipulated and digitally coloured in Adobe Photoshop.

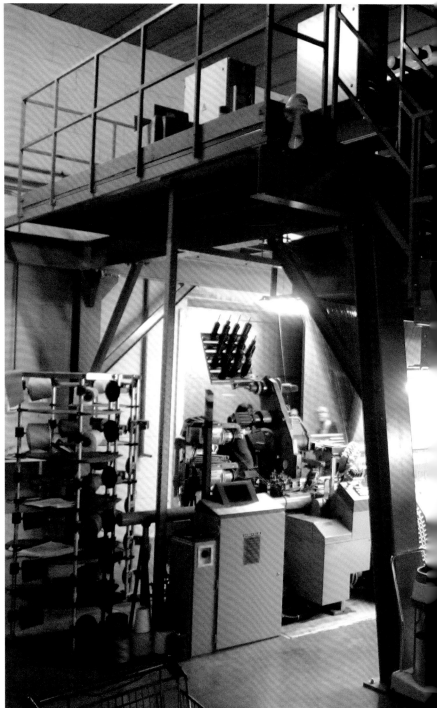

Stacked threads (above) and a modern day loom (right) at Flanders Tapestries, Wielsbeke.

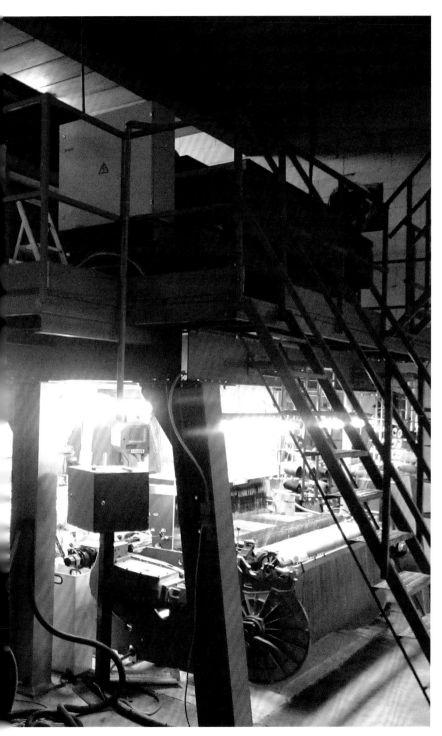

The enclosures in the drawing were 'flood filled' with colour. When an enclosure was not fully closed, however, the colours also filled the neighbouring enclosure, producing some unusual visual artifacts that Perry wanted to keep. At 'digital mediator' Factum Arte in Madrid, Blanca Nieto corrected distortion in the scan, removed unwanted pixels, worked on the structure of the lettering so that it remained legible after weaving, and started working on the printed colour references for Flanders Tapestries, the weavers, based in Wielsbeke, Belgium.

Initial weaving tests were carried out and a colour palette identified. Yarns are usually bought raw and the colour shades chosen in conjunction with the artist. All the yarns are then dyed to get the highest possible colour fastness value, this will differ depending on the yarn material and color shade. Colour fastness is a complex issue, and all of the threads used in Grayson Perry's tapestries are optimised for light resistance (to the detriment of water resistance); this means the tapestries are more resistant to light than water. To produce the colour charts, a selection of 12 dye colours is made (plus four tones for the weft yarns). A grid of weave patterns (all the possible interlacing patterns between the yarns) is then used to produce the colour chart or 'flag' of colours available, consisting of several hundred little patches, numbered and lettered according to columns and rows. Once a colour gamut is agreed, it is shown to the artist for approval.

When the image is woven, the result is a 'mosaic' of yarns crossing one another, which visually re-composes the original image while transforming it into the language of tapestry. How this mosaic works, both close up and from a distance, is critical. The range of colours – both real, flat, and perceived, optical mixes – is further enhanced by the use of different weaves and tensions to produce a relief surface. Perry is involved

in all artistic decisions about the look and feel of the tapestry. He is involved in some but not all of the technical research into how this is achieved. At this stage the essential ingredients are trust, experimentation and communication, a dynamic worth noting because of its enduring tradition within the history of weaving, stretching all the way back to medieval times. Perry works in London, I am in Madrid, and we are both English. Blanca Nieto is Spanish. Nieto, Perry and I usually communicate in English. I talk to Roland and Christian Dekeukelaere – skilled Flemish weavers running Flanders Tapestries – and they work with Marcos Ludueña-Segre, who prepares the weaving files and works on the colour combinations, weaving structures, thread type and other details that condition the appearance of the tapestry. Ludueña-Segre is from Argentina and communicates with myself in English and Nieto in Spanish. The shared language is that of tapestry. The artist Craigie Horsfield, who works closely with Flanders Tapestries, calls this process 'weaving together diverse social strands of experience'.

From start to finish the process is one of adjustment: to the colour (both flat and optically-mixed colours); the textures; the character of the weaving; the volume or depth that is required; and the sheen or matt-ness of the threads (many different threads are used, including chenille, cotton, mercerised or pearlised cotton, silk, wool and a range of synthetic fibres). All of these decisions condition the final result.

In the case of the *Walthamstow Tapestry*, the final look – similar to a quilting – was achieved by tightly weaving the black lines and varying the density of the weaving on the coloured areas of the design. In retrospect this was the obvious solution, as it mimicked the process by which the drawing was made.

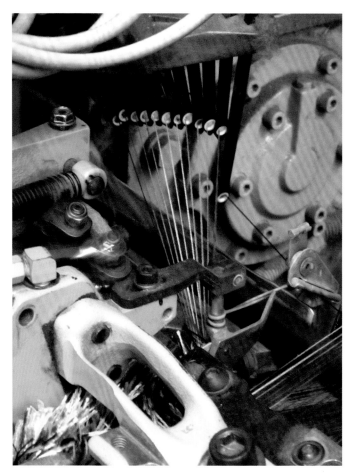

Perry watches *The Adoration of the Cage Fighters* (2012, p. 67) come off a loom at Flanders Tapestries, Wielsbeke (right). Still from *All in the Best Possible Taste with Grayson Perry* (2012), produced by Seneca Productions for Channel 4.

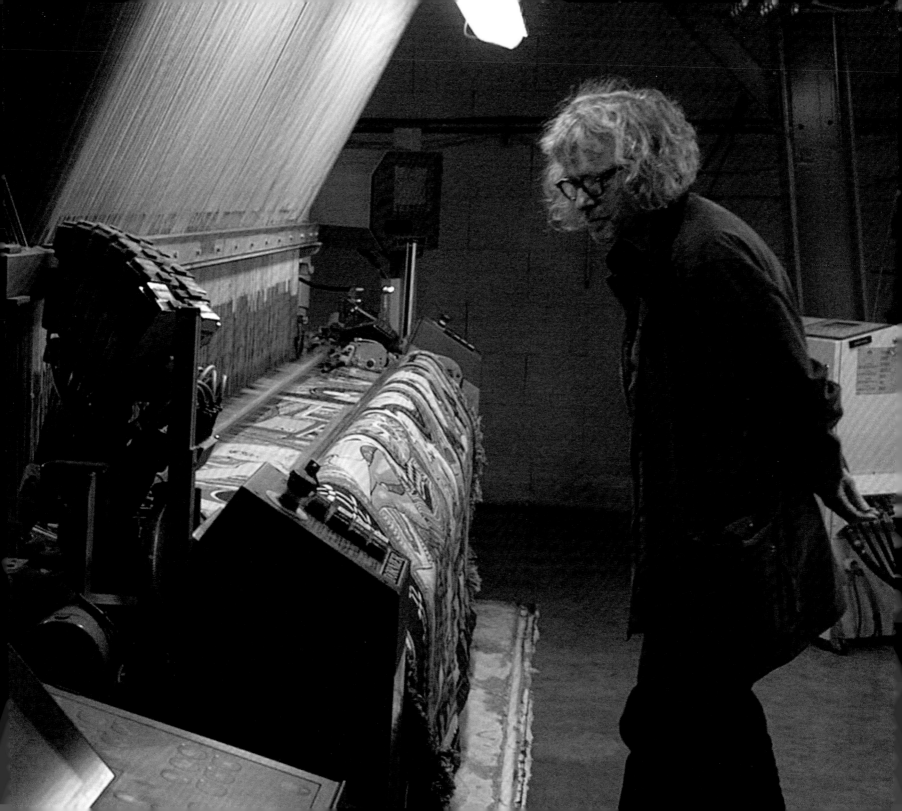

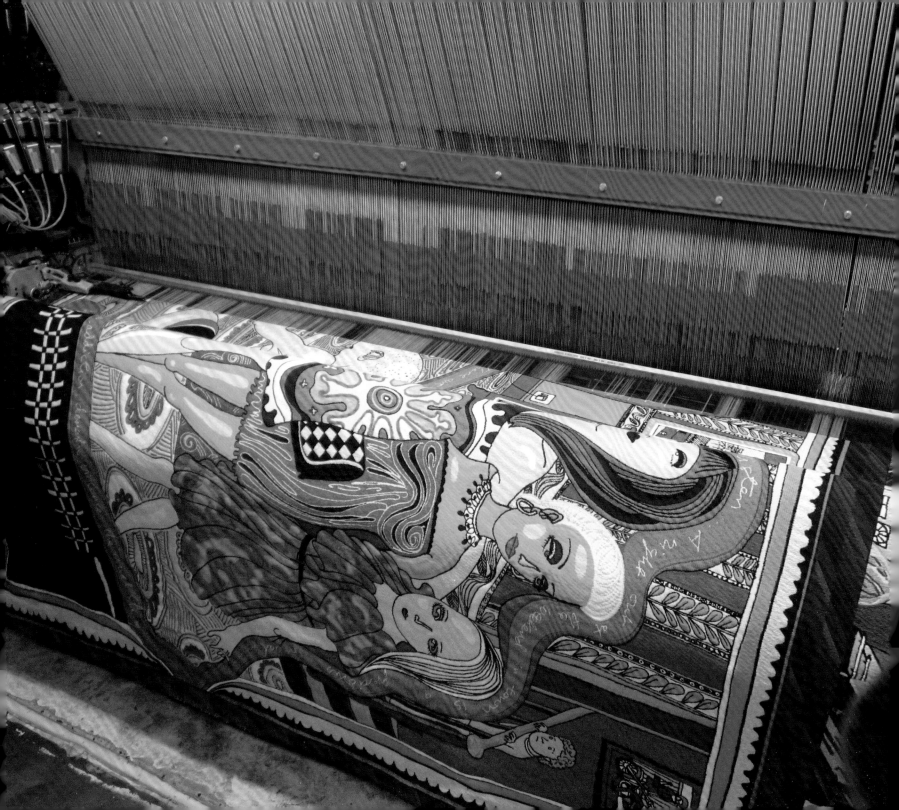

My Friday night co-revellers from Sunderland, in front of the image they inspired: from left to right, Katherine Adamson, Debra Anne Ratcliff, Laura Gooch and Jean Ratcliff.

The quilted feeling was produced by 'using' the threads that are not visible on the tapestry surface. Due to the character of the colours used, there were seldom more than three or four threads visible on the surface at any time, the rest of the yarns, however, were still 'passing through' underneath the surface. These yarns were made to work even when not visible, bending the fabric in a concave and convex way. This approach has its limitations, but it gives an extra dimension to the feeling and look of the tapestry.

The loom used at Flanders Tapestries is made by Dornier. The Jacquard mechanism is made by Gosse. When working on a Jacquard loom the 'loom language' is, and always has been, digital. The loom only 'understands' binary commands, whereby warp threads go up or down before each weft (cross-ways or latitudinal) thread is interlaced. A combination of standard software, specialised textile software, and Flanders Tapestries experience and willingness to experiment, is used to produce the tapestry. After the programming and proofing work is complete, the task of the loom operator and the loom is to keep everything standardised, repeatable and faultless. The operator needs to remain in constant control of the weaving and avoid the shortcomings and flaws that are inevitable in such a complex interlaced weaving.

A similar procedure was used to produce Perry's *The Map of Truths and Beliefs* (2011, Paragon Press), first exhibited as part of *Grayson Perry: The Tomb of the Unknown Craftsman* at the British Museum in 2012. However, by the time work started on the series *The Vanity of Small Differences* (2012), Perry had moved on to producing the entire initial drawing on his Wacom Cintiq interactive pen display. The black outlines have gone; the mastery of drawing directly on the computer screen with a digital pen has created a new graphic language – every mark made in the knowledge that it will be transformed into tapestry. These drawings are to the final Jacquard weaving as Raphael's

cartoons are to the tapestries made in Pieter van Aelst's workshop in Brussels (or those woven, later, for Charles I in the workshops at Mortlake in the UK). The narrative works that make up the cycle of six tapestries have a fluency in which Perry pushes the visual colour mixes to the limit and uses the weave structure to create volume and shadow. The works are digital – from conception to finished tapestry. Jacquard weaving has an elegance that makes the muses happy – it was the inspiration for the computer and is still one of the most beautiful methods of digital output. As we head into the age of 3D printing, a system that can actually weave data is both a role model and an inspiration.

In discussions with Jerry Brotton during the process of curating *Penelope's Labour; Weaving Words and Images*, Perry declared that tapestry had become his 'default setting', his immediate response to any artistic project, because of the way the medium matches his ideas and methods of expression.[2] It is an intensely collaborative project; it is rooted in a powerful craft tradition that stretches all the way back to the Bayeaux Tapestry (although this is technically embroidery), via medieval artisanal culture, and William Morris; it does not recognise the distinction between 'high' and 'low' art forms; and it enables Perry to continue an enduring tradition of telling highly moralised stories of who we are, whether we worship the gods of organised religion or Western consumerism.

1. James Gleick, *The Information: a History, a Theory, a Flood*, Fourth Estate, London, 2011, pp. 116-17.
2. *Penelope's Labour – Weaving Words and Images*. Fondazione Giorgio Cini, Venice Biennale, 2011.

Installation

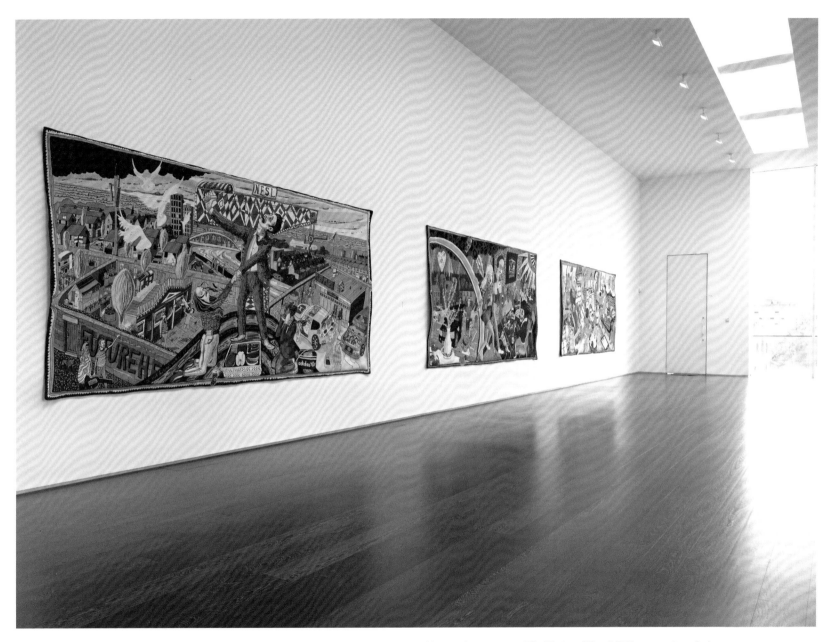

Here and pp. 114–17; *The Vanity of Small Differences*, installed at Victoria Miro Gallery, London, 7 June – 11 August 2012.

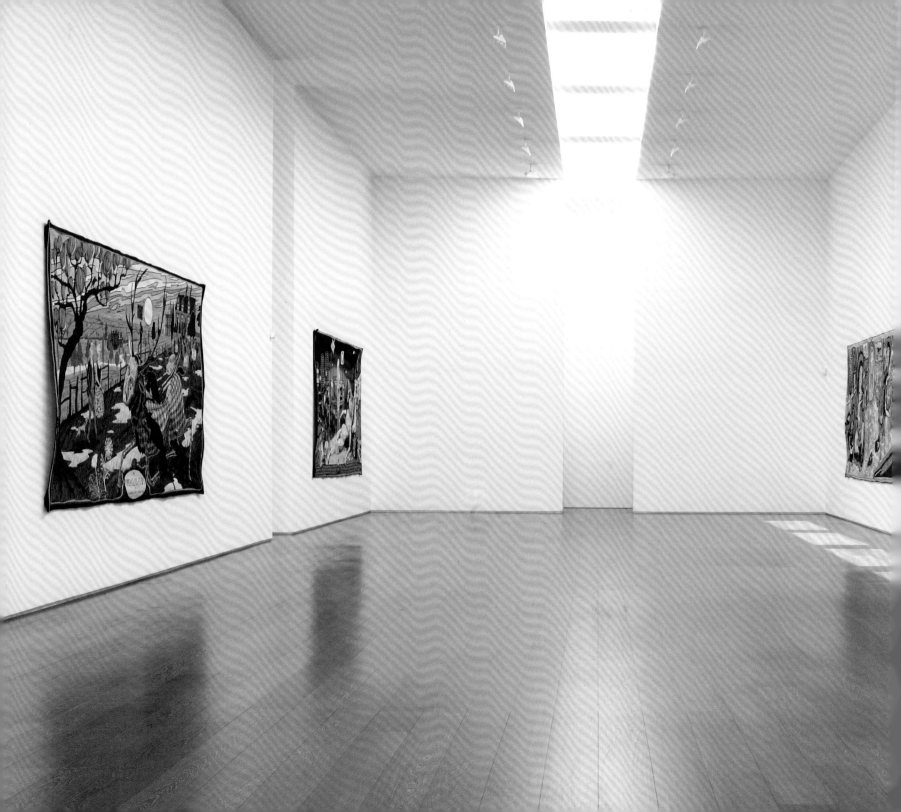

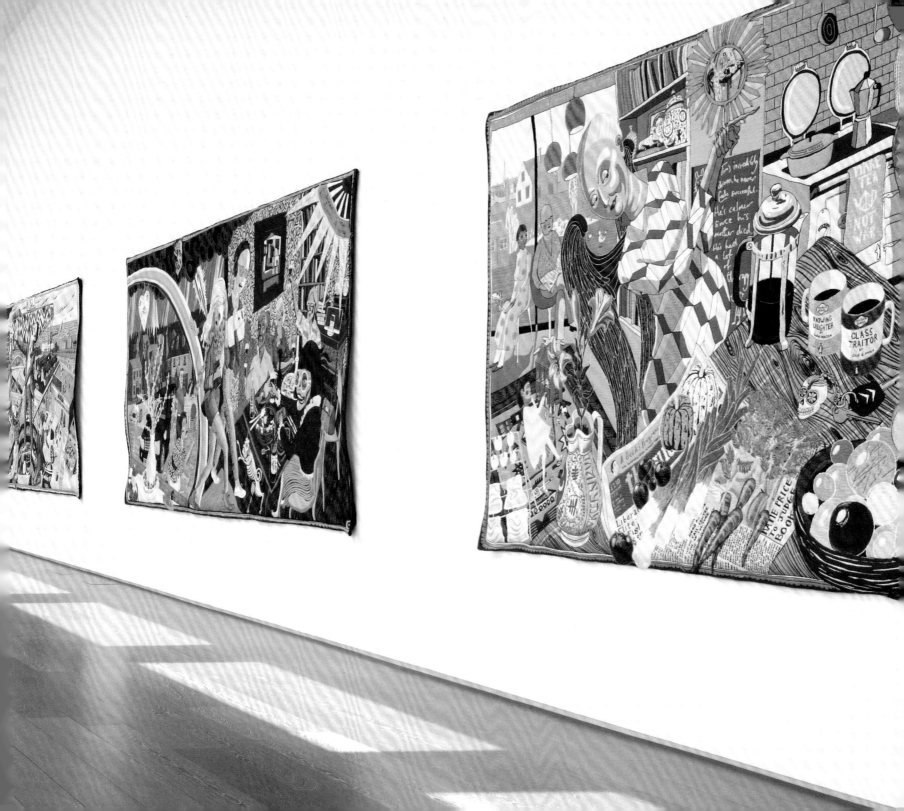

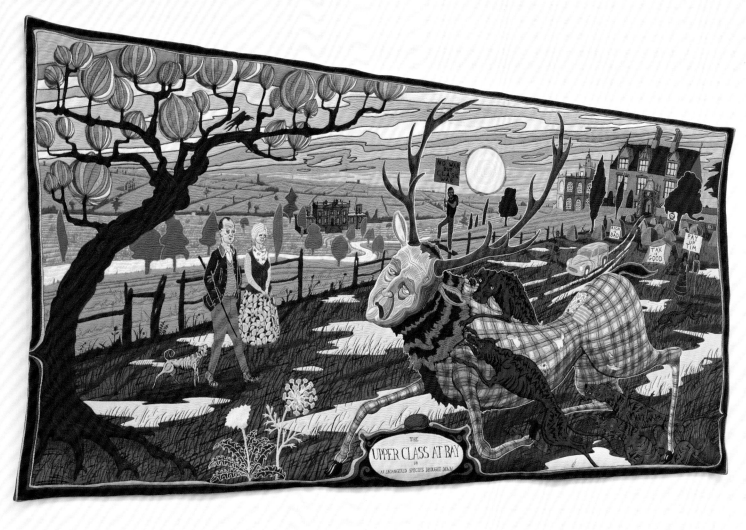

THE
UPPER CLASS AT BAY
OR
AN ENDANGERED SPECIES BROUGHT DOWN

List of works

pp. 67, 80–81 (detail)
The Adoration of the Cage Fighters
2012
Wool, cotton, acrylic,
polyester and silk tapestry
200 × 400
One from edition of six
plus two artist's proofs
ACC40/2012

pp. 71, 86–87 (detail)
Expulsion from Number 8 Eden Close
2012
Wool, cotton, acrylic,
polyester and silk tapestry
200 × 400
One from edition of six
plus two artist's proofs
ACC42/2012

pp. 75, 92–97 (details)
The Upper Class at Bay
2012
Wool, cotton, acrylic,
polyester and silk tapestry
200 × 400
One from edition of six
plus two artist's proofs
ACC44/2012

pp. 69, 82–85 (details)
The Agony in the Car Park,
2012
Wool, cotton, acrylic,
polyester and silk tapestry
200 × 400
One from edition of six
plus two artist's proofs
ACC41/2012

pp. 73, 88–91 (details)
The Annunciation of the Virgin Deal
2012
Wool, cotton, acrylic,
polyester and silk tapestry
200 × 400
One from edition of six
plus two artist's proofs
ACC43/2012

pp. 77, 98–101 (details)
#Lamentation
2012
Wool, cotton, acrylic,
polyester and silk tapestry
200 × 400
One from edition of six
plus two artist's proofs
ACC45/2012

All measurements are in centimetres, height × width.

All works are courtesy Arts Council Collection, Southbank Centre
London and British Council. Gift of the artist and Victoria Miro Gallery
with the support of Channel 4 Television, The Art Fund and
Sfumato Foundation with additional support from AlixPartners.
All works © the artist.

Published by Hayward Publishing
Southbank Centre
Belvedere Road
London, SE1 8XX, UK
www.southbankcentre.co.uk

Art Publisher: Nadine Monem
Staff Editor: Faye Robson
ACC: Jill Constantine, Senior Curator;
Victoria Avery, Acquisitions Co-ordinator;
Ann Jones, Curator
Catalogue design by Pony Ltd., London
Colour management by Dexter Pre-Media
Printed in China by C&C Offset Printing

A catalogue record for this book is available
from the British Library

ISBN: 978 1 85332 315 7

Distributed in North America,
Central America and South America by
D.A.P. / Distributed Art Publishers, Inc.,
155 Sixth Avenue, 2nd Floor, New York,
NY 10013
tel: +212 627 1999
fax: +212 627 9484
www.artbook.com

Distributed in the UK and Europe,
by Cornerhouse Publications
70 Oxford Street, Manchester M1 5NH
tel: +44 (0)161 200 1503
fax: +44 (0)161 200 1504
www.cornerhouse.org/books

Cover: *Expulsion from Number 8
Eden Close*, 2012 (detail)

ARTS COUNCIL COLLECTION AT
SOUTHBANK CENTRE

BRITISH COUNCIL | Collection